HAUNTED SUMMERVILLE, SOUTH CAROLINA

BRUCE ORR

Haunted America

Published by Haunted America
A Division of The History Press
Charleston, SC 29403
www.historypress.net

Cover image courtesy of Kayla Orr, KOP Shots.

Images are courtesy of the author unless otherwise noted.

First published 2011

Manufactured in the United States

ISBN 978.1.60949.224.3

Library of Congress Cataloging-in-Publication Data

Orr, Bruce.
Haunted Summerville, South Carolina / Bruce Orr.
p. cm.
Includes bibliographical references (p.).
ISBN 978-1-60949-224-3
1. Ghosts--South Carolina--Summerville. I. Title.
BF1472.U6O74 2011
133.109757'94--dc23
2011023477

To my mother, for putting up with all those ghost stories throughout the years.

To my sisters, for putting up with me.

To Mrs. Haltiwanger, Angie's mom, for all those ghost tales we used to share when I was a teenager. Wish you were still here to see me sharing them with others.

CONTENTS

CONTENTS

A WORD ABOUT GHOSTS

G hosts. The mere mention of that one particular word to a person can bring about a variety of reactions. Those reactions can range from disgust and disbelief to interest and intrigue. Sometimes you will encounter that rare occasion when you will be surprised by the response, "Would you like to hear about ours?" Trust me, in the past year of research on this project, I have received them all.

I recall one incident in particular during research for this project. I walked into a local business, identified myself as an author and explained my intent to the proprietor. When I mentioned "ghosts," she looked at me as if I were one of Summerville's palmetto bugs. Her expression of absolute disgust conveyed an overwhelming desire to squash me underfoot. In keeping with the imagery, I scurried out of that place and back onto the sidewalk as fast as my legs could carry me. As I departed her establishment, I snickered at the thought that if she had turned her snooty little nose up any higher, it would have gotten caught on the ceiling fan that spiraled high above our heads. The thought of this uppity, indignant, hoity-toity proprietor suspended by her nose and spinning around the room amused me. Even now, I snicker as I think about it.

Fortunately, she was the one exception to the rule in Summerville.

The residents of Summerville—the living ones—are as warm and friendly as one would come to expect from a city nicknamed the "Flower Town." I had several wonderful experiences meeting with the citizens and interviewing them about their ghost legends, history and folklore. After having tea at

This Whole House Tea Room, I can understand why Mary Helen chose to stick around instead of moving on to the other side. After spending a day in Guerin's Pharmacy sitting at a table in the back and talking with Mr. Robert Anderson and Charles Dunning, I felt honored to have these gentlemen share their life experiences with me. It was truly a privilege. I now understand why the ghosts at Guerin's Pharmacy remain.

Indeed, why wait to die to haunt a location? Great authors like Poe and Hemingway had their particular haunts while they were living. As an author, I may not ever be considered as great as these masters, but like them, I have established my favorite bar in Summerville, to which I often retreat and ruminate on my next book or project. Visit Montreaux's Bar and Grill, and although you may not always encounter Monty, you just might find me hiding at a table in the back with a beer, a burger and a laptop.

For the better part of two decades, I was fortunate enough to call Summerville my home. Perhaps I will return there when I die. Perhaps, like many of the spirits discussed in this book, I will stick around for a while after that. Maybe I will join Mary Helen at This Whole House. She seemed to take an interest in me. I am sure that haunting a former brothel with one of its, er, *entertainers* would be quite interesting. Perhaps she could teach me a trick or two.

In researching a topic for a book, I decided to investigate some of the legends that I grew up with in the Lowcountry of South Carolina. I started with Charleston and its ghost stories. There are a vast number of books related to this topic. In fact, there are so many that they repeat themselves. I then looked into Summerville ghost stories. In researching that topic in the local Summerville library, I ran a search through the computerized system. The result was a grand total of two books. Out of those two books, there was one that contained absolutely no stories about Summerville. The second book contained just one. So, in the entire library, there was actually only one story in one book about one Summerville ghost. That was quite distressing, and the actual irony of the matter is that this particular library is rumored to be haunted. No wonder there are claims that the ghosts throw around entire rows of books for attention. I would too!

Being an investigator, researcher and author of the topics I choose, many folks inevitably ask me my opinion in regard to the paranormal and the existence of ghosts. My answer to that is quite simple: it's complicated.

If the person or persons posing that question smile and regard my answer as evasive, then I let them go with a chuckle. If they persist, they invite themselves for the lecture that you, dear reader, are about to receive.

A Word About Ghosts

The word paranormal does not equal ghost. Paranormal is something beyond reasonable explanation or our ability to explain as normal. It does not mean that it is *un*natural. It is simply something that naturally occurs that we are not yet able to explain in an accepted scientific manner. There are things occurring every second that modern science has yet to explain. If you think everything in the realm of human experience can be scientifically explained, then you are deluded. Even the things that we take for granted as scientifically acceptable are subject to reevaluation and change as time advances. What we accept now may be laughed at as ridiculous in the next century. Here is a case in point, as explained by J. Allan Danelek in his book *The Case For Ghosts: An Objective Look at the Paranormal.* I consider this one of the most compelling views in the field.

In the nineteenth century, accepted medical science believed that illness and disease were caused by poisoned blood. The impurities had to be removed, so the medical professionals of that time did so by extracting the contaminated blood. This was accomplished in various manners. The simplest would be cutting the person and letting the blood flow. A more ingenious method was to attach leeches and have the disgusting vermin suck the blood out of the patient. Being an outdoorsman, fisherman and scuba diver, I can assure you that these are not cute, pleasant and cuddly little creatures to encounter. Quite frankly, I consider them to be slimy little vampires from the fiery pits of hell.

In 1799, the father of our country, George Washington, developed pneumonia after suffering a bout of laryngitis. As he lay ill, the finest doctors were brought in to help him. Their solution was to purge the former first president of his poisoned blood. In fact, up to a pint of the man's blood at a time would be removed several times daily. Despite their best efforts, the former first president died.

In the mid-nineteenth century, one scientist challenged everything that medical science believed in. The chemist stated that illness and disease were not caused be poisoned blood. He stated that they were caused by organisms that were invisible to the naked eye. He called these organisms "germs." He also went on to say that the process of bleeding a sick patient was actually detrimental to the person's health and did far more harm than good. He said that by removing the blood, the physicians were actually weakening the patient and depleting the body's natural ability to fight off the disease. He even went so far as to say that many of the doctors' procedures were inadvertently killing their patients. As you might imagine, that did not go over extremely well in the medical community. As a general rule, physicians

are not particularly overjoyed to be accused of harming, much less killing, patients they are trying to cure.

This scientist was labeled a heretic. The man saw his hypothesis rejected as lunacy and nonsense by the established medical community. His invisible "germs" were labeled ghosts and discounted. If one cannot see these creatures, then how can one possibly prove they exist? Still, he persevered and eventually created a number of experiments to prove he was correct on all accounts. Eventually, an instrument was created that was able to magnify the chemist's "ghosts" to the point where the human eye could see them. That man, Louis Pasteur, was eventually vindicated by those experiments.

Today, Louis Pasteur's contributions, such as immunization and pasteurization, are taken for granted. The fact that this man, considered to be one of the founders of microbiology, has saved *millions* is readily accepted. The idea of bleeding someone with leeches causes one to shake his or her head and laugh at the sheer ignorance and lunacy of nineteenth-century science.

With the invention of the microscope, Pasteur's little ghosts were actually proven to exist. Perhaps those who laugh at and ridicule those who crawl around in haunted places will be proven wrong in the next century. Perhaps there is a Pasteur among us who will prove the existence of another type of ghost, one that is the remnant of a once-living human being.

Many people laugh at the paranormal researcher chasing ghosts with instruments designed for other purposes. As one such investigator put it, in the early days people used stones tied to sticks to chop notches in logs to build houses. Nowadays, builders use power saws and pneumatic nail guns specifically designed for that purpose. Paranormal investigators simply use what they have at hand until something better is created for the sole purpose of proving the existence of ghosts.

Having said all of that, I still remain skeptical.

Having been both a veteran law enforcement officer and a researcher into these stories and legends, I can honestly say that I have seen all manner of the unexplainable. I have heard things and experienced events, some of which are written in this book, that defy normal explanation and branch off into the *para*-normal field I discussed earlier.

On one hand, I am able to debunk certain tales rather easily, such as the rumor that the Woodlands Inn is haunted by Vice President John C. Calhoun. The fact is, he died in 1850, and the inn was built in 1906, fifty-six years after his death. That haunting is a myth. The reality is that the Woodlands Inn is a Five Star and Five Diamond Hotel and Restaurant, one of only six in the entire country. There is no ghost—well, at least not that one.

A Word About Ghosts

On the other hand, there are several other experiences I have had that are not so easily explained and dismissed. Am I ready to rubber-stamp them as ghosts? The answer is no. Do I believe in ghosts? The answer is that I have not been convinced of the existence of ghosts. I do, however, believe in the possibility of ghosts existing.

Haunted Summerville, South Carolina, is a collection of stories taken primarily from the citizens of Summerville, South Carolina, themselves. Unlike other ghost tales, the majority of these stories will not be found in other publications. I am not saying there are not any publications regarding the ghosts of Summerville—because there are. There are just no compilations entirely dedicated to this wonderful city's paranormal inhabitants. From phantom planes to ghosts with trains, the stories here are mostly passed on by word of mouth. In fact, in preparation for this book, I would often interview one resident about his particular haunting, and then he would inform me that I needed to speak to another Summerville resident about her ghost.

I am a writer and an investigator. I not only research the topics that I write about, but I actually go out and interview those involved and investigate the locations as well. I am not, by any means, a ghost hunter or paranormal investigator, and I make no claims of validating or refuting the stories contained in *Haunted Summerville*. They are strictly stories as they were relayed to me. It is up to each individual reader to determine his or her own beliefs about the existence of ghosts. It is not my intent to either prove or disprove their existence.

As a former law enforcement investigator, I am more analytical and systematic in my approach to things. I am truly of the train of thought that seeing is believing. I have often said that I will firmly believe in ghosts when one sits down at a table across from me and joins me for a cup of coffee. I was quoted as such in numerous interviews, including a recent interview for an article in the *Summerville Journal-Scene*. Apparently, this raised the ire of one Summerville resident, a staunch believer, who later stated to me, "As long as you keep sticking your nose in the places that you do and researching the things that you do, the proper etiquette would be for you to bring the pastries. I assure you that one day there will be a southern spirit with a cup of coffee waiting around the corner, and you had best be adequately prepared."

I took her advice, and now I always carry a Little Debbie raisin cake or coffee cake in my equipment vest when investigating new locations—just in case. You never get a second chance at a first impression.

ACKNOWLEDGEMENTS

I would like to thank the following people and organizations:
Alessa Bertoluzzi of the Summerville/Dorchester Museum, for her insight into the stories "Montreaux's Mischievous Monty" and "The Summerville Light."

David Price, for taking time to meet me for an interview and providing his insight into the Price House Cottage and the story "Extended Stay."

Alkinoos "Ike" Katsilianos of Darkwater Paranormal Investigations, for his continuous assistance and expertise in all things paranormal and the Summerville National Guard Armory investigation and for his input into the story "Permanent Duty Station."

Ashley Chapman, park ranger with the South Carolina State Park Service, for his time and information regarding the history of Old Fort Dorchester State Park, the fort, the town itself and the bell tower of St. George's Church.

Charles Dunning, Barbara Dunning and Peggy Neal, for their information on Guerin's Pharmacy for "The Ghosts of Guerin's."

Robert Anderson, certified public accountant, for his interview and input into the stories "The Man in the Gray Business Suit," "The Phantom Flight Over Summerville" and all things Summerville.

Dennis Ashley and the staff of Dennis Ashley Architects, for their assistance with "The Man in the Gray Business Suit."

Judy Thomas, Mecia Brown and the staff of This Whole House Tea Room, Antiques and Gift Shop, for their interviews and input in the story "The Ghost Who Stayed for Tea."

Eric Price and Niki Schoffner of Montreaux's Bar and Grill, for their interviews and help in "Montreaux's Mischievous Monty."

Debbie Lodge and the staff of the Timrod Library, for their information and input into the story "Don't Judge a Book by Its Cover."

Eva Garriott of the Dorchester County Public Library for information and input into the story "Don't Judge a Book by Its Cover."

The staff of the George H. Seago Jr. Branch of the Dorchester County Public Library for input into the story "Don't Judge a Book by Its Cover."

The receptionist staff at Parks Funeral Home for their time and commitment to the Summerville Cemetery and the story "Gifts to a Crying Child."

The Summerville Preservation Society and its president, Heyward Hutson. He is truly a living archive of Summerville history.

The staff at the *Summerville Journal-Scene* and reporter Leslie Cantu, for her November 12, 2010 article "Ghost Stories Wanted" regarding this project.

Ryan Hamm and the Summerville Kiwanis Club, for the opportunity to speak at their meeting about this project.

Donna Wenberg, for research into "The Phantom Flight Over Summerville."

The Air Force Historical Studies Office.

Jonathan Stout, photographer, for use of his photograph and input into the story "Permanent Duty Station."

Sandra Baden and the Friends of the Summerville Library.

My darling daughter Kayla Orr of KOP (Kayla Orr Photography).

Author Debbie Applegate, for her information and insight into the Beecher family.

Michelle List, for inviting me into her home and for crawling around with me underneath it searching for a lost grave.

Author Fern Michaels for taking the time to converse with me about the paranormal.

Matt Owens of Salamander Property Management and the Woodlands Inn for his valuable time.

Radio personality Brooke Ryan, for her support.

Radio personalities Janet Walsh and Lauren Raycroft of *Moms in the Morning* on 98.9 Chick FM.

Staff reporter David MacDougall of the *Post and Courier*.

Amber Clarkson of Palmetto State Paranormal.

Jenn, Teresa, Wanda and the rest of the staff at the Summerville branch of Physician's Plan Weight Loss, for allowing me an opportunity to talk about this project.

Karen Horne, for her contribution to this project.

Suzanne "Wow" McConnell, for her artistic interpretation of my encounter with the Summerville Light.

Nick Smith and Erica Jackson Curran of the *Charleston City Paper*.

Introduction
Summerville, South Carolina

The Flower Town in the Pines

Before one can explore the legends and lore of the town, one must understand how the town itself actually came into existence. Perhaps then one may fully understand how, metaphorically, the Angel of Death, or the human desire to escape one's own death, became a common and continually repeated theme throughout the town of Summerville's history.

In 1697, a group of Congregationalists, a religious denomination, created a little village along the banks of the Ashley River and named it Dorchester, after the town in England where their denomination was created. They had fled the former Dorchester many years earlier to avoid religious persecution and execution. They were literally fleeing death.

Through the centuries, England had known its fair share of death. It had seen the Black Death, during its climax between 1348 and 1350, decimate 30 to 60 percent of Europe's population. During this time, it is believed that the entire world's population was actually reduced from an estimated 450 million to a little over 350 million by the year 1400. This created a series of social and economic upheavals throughout Europe. It also created religious upheaval and divisions in belief. The town of Dorchester was not immune to the Black Death, and it seems that the Angel of Death himself decided to take up residence there.

In 1613, the town was almost completely destroyed by fire. The building designs of that era were immensely flammable, and the flames spread very rapidly among the timber and thatched roofs. Three hundred homes were destroyed. Again, the Angel of Death decided to demonstrate his power as

Summerville, South Carolina: "The Flower Town in the Pines."

destruction came to the town of Dorchester. But somehow, the little town managed to persevere and recover.

By 1665, death had left Dorchester and was taking a holiday in London. In a three-month period, from June until August, 15 percent of London's population was infected and died. As the plague continued to ravish the city, the Great Fire of London struck in 1667. The fire destroyed most of London. In an ironic yet merciful twist, it also annihilated the rat population that carried the fleas infected with the deadly bubonic plague. It was fire that almost destroyed the town of Dorchester in 1613, but this time, it was also fire that saved it by preventing the spread of the deadly plague and keeping it confined to London.

In 1685, the Angel of Death once again came back to visit the town of Dorchester. The town was one of several villages that actually became a center for religious persecution. It was part of what would be known as the Bloody Assizes. The Bloody Assizes were a series of trials conducted by five judges led by Lord Chief Justice George Jeffreys. They traveled across England and throughout these villages conducting trials on rebels deemed

not loyal to the Crown or the religious beliefs of the state. Thousands were sentenced to death. The execution methods ranged from the prisoner being beheaded, hanged or drawn and quartered. Some were also burned alive. Their remains were placed on display as an example to those who might oppose the Crown. Many more were imprisoned and enslaved. Lord Chief Justice Jeffreys became known as the "hanging judge," and King James later appointed him Lord Chancellor for his services to his country, the Crown and God. By exterminating those who exercised a different belief system and bringing the country in line with King James's rule, Jeffreys was considered to be doing the work of God, and it was an effort befitting honor from the king himself.

By this point, a small group of 140 people had fled the town of Dorchester under the direction of Reverend John White. They established a colony in Massachusetts and named it Dorchester after the English town they had fled. It was from this location that a missionary group was sent to "settle the gospel" in the Lowcountry of South Carolina. Again, they founded a village and named it Dorchester. It would be the third and final incarnation of the town.

The new town contained a church and a Free School and also became a center of trade and commerce in the area. It prospered, and about 1760, a fort was created out of tabby, a type of mortar mixed with oyster shells, lime and sand. In 1770, the fort became a magazine for the state's gunpowder supply during the American Revolution. By 1775, it had been fortified, and the garrison there was commanded by Captain Francis Marion, nicknamed the "Swamp Fox" by the British for his guerilla tactics. When Charles Town fell to the British in 1780, Dorchester also fell under British command and became an outpost for the British redcoats. The town was abandoned in 1781 as Colonel Wade Hampton and General Nathanael Greene drove the British out. The British destroyed most of it as they fled. Again, death came back to the town of Dorchester. This time, it came in the form of war.

Some believe that once the Angel of Death completely destroyed the town, he succeeded in his mission to end all future incarnations of the town of Dorchester. Some believe that the Death Angel remained there with the remnants of the now-abandoned town.

Much like its English namesake, the South Carolina town of Dorchester dreaded the onset of summer. Summer always brought an onslaught of illnesses and epidemics. The colonists were also plagued by an onslaught of mosquitoes during the summer months, much as the English experienced an

increase in fleas. Today, we understand that the summer months naturally bring about the breeding and hatching of insects. We also now know that the fleas carried the bubonic plague that decimated Europe and that the mosquitoes carried the malaria that killed so many colonists in this country. The swampy areas of the Lowcountry, where the plantations were, created the perfect breeding ground for the deadly mosquitoes. The connection between the arrival of the mosquitoes and the simultaneous arrival of the epidemics was never made by the early settlers. All they knew was that summer brought death.

Captain James Stewart was a militia officer and rice planter. While on a hunting excursion, he found himself several miles inland from his Beech Hill Plantation. He decided to head to higher ground and remain overnight before trying to make his way back to his plantation home. He inadvertently stumbled across and located an area filled with longleaf pines. He noticed that the looming pine trees' fragrance filled the air. He also noticed that the temperature was much cooler there than back at his plantation at Beech Hill and that the area was mosquito free.

The area that he found was a piney ridge about seventy feet above sea level. The area was between the Ashley River and the Cooper River, and the elevation was high enough to catch the breezes that circulated between the two. What he did not know was that the sandy area did not hold pools of water like the marshy areas did. The water either was absorbed or ran off and evaporated. Without the pools of standing, stagnant water, the mosquitoes had nowhere to breed.

The captain mapped out the area as he returned to his home. A short time later, he returned to the spot he had located and built a rough summer home. The style of home was, ironically, known as a "mosquito house." The house was built about eight feet off the ground to catch breezes and keep out bugs. It had a center hall with two rooms on each side to allow for cross ventilation during the summer months. If the house had a second floor, it was built exactly as the first. Each room had a fireplace for heating during the winter should the house be utilized.

Many of Captain Stewart's militia group soon followed him in building summer homes at the location. Soon, word spread of the benefits of the area, and many other plantation owners also built mosquito houses there to escape to during the summer. The summer homes continued to grow in number until they became an actual "summer village." Soon, the town would be known as "Summer-ville." Although it continued to grow and develop, it would actually not be incorporated into a town until much later.

Its incorporation occurred in 1847, and the town members adopted the Latin phrase *Sacra Pinus Esto* as their motto. Translated, the phrase means "Let the Pine be Sacred." The citizens did indeed realize the importance of the pines, and the following year, their new council would further honor the trees by creating the first protective tree ordinance in this country. No one could cut down a tree on his personal property without first petitioning council and giving specific reasons. The tree would then be inspected, and permission would be granted or denied. Noncompliance to the protective ordinance would result in large fines and possibly even jail time. Similar ordinances are still in effect in Summerville to this day.

In 1925, a contest was held to improve the slogan. When Virginia Lowndes Bailey won her five-dollar prize for creating the new town slogan, "The Flower Town in the Pines," I am quite certain she had no idea that the slogan would carry the city through the next eighty-six years.

The original colonists had fled the English town of Dorchester and founded the South Carolina town of Dorchester to escape death. The colonists eventually fled the new town of Dorchester to avoid death at the hands of the British, and the British then fled and destroyed the town to avoid death by the colonial militia. Now it was the militia's turn to flee death. It was this continuous desire to escape death that led to the creation of Summerville. It would be repeated during the Civil War as Charleston residents fled the Northern occupation of their town and took up residence in Summerville. It would again be repeated after the war when the first International Tuberculosis Congress in Paris named Summerville as one of the two best places on the planet to assist in the natural recovery of lung and heart diseases. It was believed that the pines released derivatives of turpentine into the air and that by breathing these derivatives, the patient's chances for recovery increased. The claim gained worldwide attention, and Summerville entered into what would be known as the "Age of the Inns."

As inns and "health resorts" grew by the scores, many people from around the world flocked to Summerville in an effort to defy death. Some did, but most did not. Once again, Summerville became the place to hide from the grasp of death.

Perhaps the fact that Summerville, since its beginning, has been considered a sanctuary from death is what keeps those who do die from moving on. The natural beauty of the pines and the azaleas, the hospitality of its residents and the tranquility the town provides to the living may be a combination that transcends death.

INTRODUCTION

When one dies, it is said the spirit goes to one of two places. If you are judged worthy, you go to heaven. (It is also said that to experience the South *is* to experience heaven. Perhaps that is why so many ghosts linger here.) If you die and are judged unworthy, you go to hell. (I guess that must be a city somewhere up North.)

I

LEGENDS

GHOSTS, POLTERGEISTS AND OTHER THINGS THAT GO BUMP IN THE NIGHT

THE RUINS OF COLONIAL FORT DORCHESTER: SOUNDS FROM THE PAST

In 1697, the town of Dorchester was laid out as a market town by the Congregationalist colony. It contained 116 quarter-acre lots, a commons and a town hall. An Anglican church, St. George's, was created in 1720. Hoping that economics would increase the growth of the town, in 1723, the colonial legislature decreed that weekly markets would be held in the town's commons and that a four-day fair would be held biannually. Every April and October, the fair would attract many visitors and increase commerce for the town.

A Free School was created in 1734. Despite the name, the Free School offered free education to only a few poor students while all others paid tuition. The town did eventually become a trade center and had approximately forty houses by 1781.

In 1757, a brick powder magazine was built, and an eight-foot wall was built around it. The wall was created out of a mixture of oyster shell, lime and sand. This substance was called "tabby." During the American Revolutionary War, the town of Dorchester became an extremely strategic spot. In 1775, it was fortified, and a garrison was attached to it under the command of Captain Francis Marion. Francis Marion was known to the British redcoats as the "Swamp Fox." He was nicknamed this by a British officer. Lieutenant Colonel Banastre Tarleton tried to flush Francis Marion and his men out of the swamp. After pursuing them

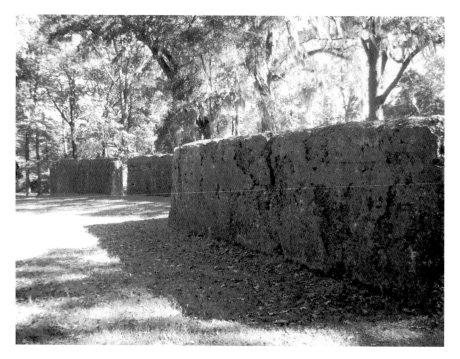

The ruins of old Fort Dorchester.

for twenty-six miles throughout the swamp, Tarleton described Francis Marion's elusiveness as that of a swamp fox.

When Charles Town fell to the British in 1780, the town of Dorchester also fell under British command and became an outpost. Dorchester had once been a thriving marketplace and a hub of commerce in the area. The spring and fall fairs did indeed bring in a multitude of people from other settlements. It is truly amazing how a once-thriving town could just fade from existence.

Today, little remains of the original structures. The bell tower of St. George's Church remains and will be discussed in greater detail in the next section. A foundation of a residence and the walls of the tabby fort also remain. They are the sole remnants of the bustling market town that was the predecessor to the town of Summerville—or are they?

State park ranger Ashley Chapman has been assigned to the park for quite some time. He states that he has never heard any of the tales associated with either the bell tower or the old fort and has never encountered anything remotely out of the ordinary or paranormal at

the location. On the other hand, some visitors have claimed that at times you can hear voices inside the walls of the old tabby fort. Others have reported hearing the sounds of horses and their hoof beats around the outer perimeter of the fort.

Some other visitors have reported the sounds of children laughing and playing around the bell tower. They have looked for the children and could not find them. A group of young men claim that a more sinister entity lurks near the bell tower and in the woods behind it.

When the British occupied the area, they used the tombstone of James Postell as a chopping block to butcher their meat. Some people believe that they disturbed Postell by desecrating his headstone and that he was awakened from his eternal sleep by their actions. He is said to patrol both the bell tower and the graveyard, trying to maintain the peace and sanctity of the area. Apparently, he does a wonderful job for the most part because the location is an absolutely fantastic place for family outings and picnics by the river. It is extremely secluded and peaceful.

Perhaps these sounds are the product of overactive imaginations and the wind through the pines. It is quite possible that the ghost of James Postell is wishful thinking. It is also not beyond the realm of possibility that the "sinister entity" is a product of too much alcohol. Then again, perhaps there is something more to the accounts. Take a visit to the location, sit among the walls of the old tabby structure and, as you relax and admire the beauty of the area, be sure to listen carefully. Among all the hustle and bustle of the nearby Dorchester Road, you just may hear a giggling child, a trotting horse or perhaps some other sounds from the past.

The Bell Tower of St. George's Church: The Angry Man

In 1717, the Dorchester Parish of St. George was created, and an Anglican church was begun two years later. It was fifty feet long and thirty feet wide with a chancel of fifteen by five feet. In 1734, it was enlarged, and in 1751, a steeple was added. In 1765, an organ and four bells were added. When the British redcoats took up occupancy of Fort Dorchester in 1780, they also took charge of everything within the town. Redcoat soldiers had little respect for the colonists or the town. In what was considered a desecration, the British soldiers used the tombstone of James Postell as a butcher's block to chop meat. The marks can still be

seen on the grave marker to this day. Some believe that the desecration of his grave angered James Postell, and he returned from the grave to keep peace at the remaining bell tower and the nearby cemetery. Some believe that when visitors show disrespect to either the remaining structure or the graves, he returns to scare them away.

Others believe that something more sinister dwells in the woods near the tower.

When the British abandoned Fort Dorchester in 1781, they destroyed all they could. A record made by Methodist bishop Francis Asbury documents that the church was in ruins by 1788. By 1800, the majority of the bricks of St. George were scavenged, and only the bell tower remained. In 1886, the Great Earthquake split the tower and almost brought it down. In 1940, straps were installed around the tower to prevent further damage.

The tower is now part of Fort Dorchester State Park and as such attracts many visitors. Many people come to explore the historic site. On occasion, others come to search for the paranormal or to hide within the tower with their friends and be disrespectful and disruptive. This is what a group of young teenagers was doing several years ago and is exactly what the British redcoats were doing back in 1780.

The youths had gathered at dusk. They had agreed to meet in the area, park on one of the side streets and walk to the bell tower. Once there, they sat among the ruins of the tower drinking stolen beer and laughing and joking.

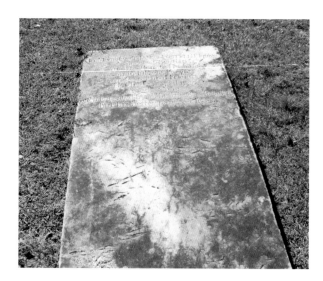

The tombstone of James Postell that the British redcoats used as a butcher's block.

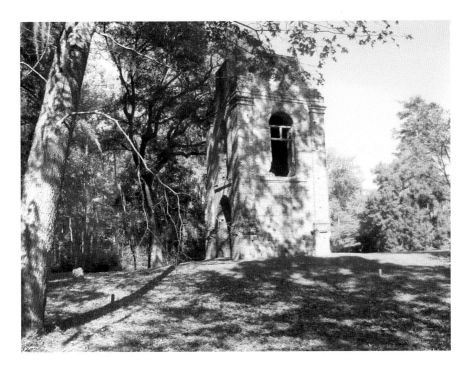

The bell tower of St. George's.

As often happens when alcohol is involved, the group got louder and more obnoxious. They began to horse around within the tower itself, and then they eventually found their loud and obnoxious roughhousing spilling out into the adjoining grave site. Several legitimate tourists would arrive periodically but would be chased away by the vulgar and obnoxious gang. The closer nightfall came, the worse the group became.

As three members of the group were busy crushing beer cans and throwing them at a tombstone, one of the boys separated and began urinating on the side of the old church bell tower. As he was relieving himself, he noticed the silhouette of a person standing at the edge of the woods behind the tower. The dark figure just stood there watching. The boy began shouting at the person and calling him obscene names. This attracted the other members of the group, who ran down to the wood line to confront the intruder. As they approached, the person simply stepped behind a tree. When they got to where he had been standing, he was nowhere to be found. A search of the area accompanied by taunts and insults produced no intruder. Satisfied that the person had managed to leave without being seen, the group returned to

the tower to resume their partying. No sooner had they reached the tower than they turned just in time to see the dark silhouette step from behind a tree. It was the same tree they had just checked behind!

Now the insults grew in intensity, and the young men ran to the tree line. Once again, the dark figure stepped behind a tree and vanished. The group searched again, and again they found no one. As they returned up the hill toward the tower, they heard an angry shout behind them. They turned to see the dark figure in the woods. This time, he was farther back. Anger overwhelmed the four young men, and their threats became worse. Their leader screamed that he would kill the man if he caught him. Once again, they ran to the woods, and once again they returned back up the hill empty-handed.

A shout from the left revealed that their quarry had moved to another area of the woods behind the tower. As the leader turned, a rock struck him in the face. It had been thrown by the intruder!

The leader was overcome with anger and immediately ran as hard as he could toward the dark figure. The other boys followed. As they reached the rapidly darkening woods, they once again could not find their adversary.

This time, the drunken and violently angry leader chose to stay hidden in the woods. He reached in his pocket and removed a knife as he crouched down at the foot of a tree just within the tree line. The other three teens walked back up the hill. Seconds before they had reached the tower, they heard a bloodcurdling scream of horror come from behind them. They turned to see their leader emerging from the woods. He was screaming and running harder than they had ever seen him run. They rushed to meet him as terror rose in their throats. Two of them stumbled and fell in their haste to reach their friend. As they were within about twenty feet of their friend, they heard another violent and angry scream that stopped all four in their tracks. This time, the shout came from the bell tower. All four young men turned, and this time the dark man was standing near the tower itself. The angry screaming filled the air, and this time the dark man's eyes were an unearthly red. It was as if his eyes were on fire. As he screamed again, the boys realized that his eyes were not on fire—they *were* fire! Within his eye sockets where his eyes should have been were flames. When he opened his mouth to release his ungodly screams, flames could be seen in his mouth.

As they watched the horrifying sight, they realized the figure was closer and moving down the hill, but he was not walking. To their terror, he was floating with his feet about a foot off the ground. The four boys tried to move, but they were frozen. Two of them actually peed themselves.

The dark man's face became consumed by fire, and then he disappeared. Instantly, all four boys ran for their two cars. When the first pair reached their car, they actually backed into the other vehicle. Both vehicles and all four boys fled the area.

A few days later, the young men met to discuss what they had seen. They asked their leader what had happened inside the wood line that had caused him to scream. The young man was quiet for a few moments. The others noticed that he began to shake. They also noticed that he began to cry. They had never seen him cry before.

Slowly, he began to speak. He told them that as they approached the tower, he began to hear voices in the woods. It was not just one voice; it was several. The voices grew in intensity and surrounded him. The voices were whispering but then turned into agonizing screams. He said it was as if he were listening to hell. As the screaming became more intense and shrill, he heard a loud voice tell him to leave. He said he saw a figure moving along the treetops, and he knew he had only seconds to react. He said he began running. The screams were involuntary, and he had no control.

The other three were stunned but said nothing. They knew he was telling the truth. The four young men believed they had defiled the church and the graveyard by their actions and vulgarity and that something had intervened to protect it.

Not a single one of them ever returned to the location.

GEORGE H. SEAGO JR. BRANCH OF THE DORCHESTER COUNTY LIBRARY: DON'T JUDGE A BOOK BY ITS COVER

Located in Summerville on Central Avenue is a very small library named after the South Carolina poet Henry Timrod. Although no documentation has been found to substantiate the claim, it is said that Henry Timrod taught in Summerville prior to the Civil War.

During the Civil War, Timrod became known as the poet laureate of the Confederacy. His poetry often invoked a sense of patriotism for the Southern cause, and poems such as "Carolina" and "A Cry to Arms" were said to have caused many young men to enlist in the Confederacy. This of course made him a hero of the South but likewise made him a target for the North. In 1865, he was forced into hiding due to General Sherman's occupation. He watched his beloved South fall to Union troops and was driven into poverty.

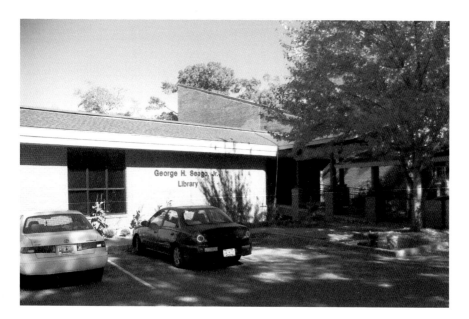

The George H. Seago Jr. Branch of the Dorchester County Library.

Because of his prose and the support he gave the Confederacy during the war, he watched his family suffer after it. After the death of his ten-month-old son, Willie, he was never the same. The grief he felt over his son's death was a burden he never quite seemed to shake. Throughout the latter part of the war, he remained extremely ill and eventually succumbed to tuberculosis in 1867.

The Henry Timrod Library got its humble start with the 1897 women's reading group called the Chautauqua Reading Circle. The women donated their used books to create the library, which had become a membership library by 1908. By April 15, 1915, the library had found a permanent home in the building where it is now located. It served Summerville citizens as its only library until the newer library, the George H. Seago Jr. Branch, was built on Trolley Road in the early 1970s.

I was directed to the Timrod Library due to its age and the tragic life of the man from whom it received its name. Surely, the age of the location and Timrod's tragic life should have some bearing on the location being haunted, this citizen advised. Perhaps Henry Timrod himself walks the floors in eternal anguish over the death of young Willie.

During an interview, I asked Debbie Lodge of the Timrod Library if the old library had any ghosts. She laughed and responded that it did not.

Then she surprised me by adding, "But the newer library on Trolley Road is supposed to and is said to be definitely haunted."

Ms. Lodge had been employed at the George H. Seago Jr. Branch for many years before moving to the Timrod Library. She had indeed herself been subject to an unusual occurrence on several occasions. When she would work late, alone in her office, she would often be startled by the sound of her closed door rattling, as if someone were trying to gain entry. She would go to the rattling door and open it, only to find no one there. There was no way someone could have had the time to run and hide by the time she opened the door. Ms. Lodge is herself skeptical and attributes the rattling more to vibrations from passing vehicles or the settling of the building rather than restless spirits.

She also stated that although she had not experienced anything other than an occasional rattling doorknob, other library employees claimed they had encountered books flying from the shelves. They said that the books would literally be converted into literary projectiles, launching themselves from the shelves and flying across the room. This was an occasional occurrence and was often explained away as faulty shelving or perhaps a minor seismic tremor, much like the explanation for the rattling doorknob. That is, until the evening one employee walked around the end of a bookcase and actually witnessed a book levitate from one of the shelves, as if being picked up by an invisible hand. The book rose into the air, remained stationary for several seconds and then dropped to the floor with a thud. The startled employee, as one might imagine, made a hasty retreat back to the main desk. Her pale appearance and her visible trembling immediately drew the concern of her colleagues, and when she was finally able to speak, she advised her stunned co-workers of her ghostly encounter.

At the George H. Seago Jr. Branch, the library employees confirmed the stories of paranormal activity that Ms. Lodge provided. In fact, one employee was a wee bit faster than the previous one. One night, she rounded the end of a bookcase and encountered a bloody, severed arm. The disembodied arm was floating among the rows of books. She did not stick around for it to choose a book to throw. She was so shaken by her encounter that she promptly resigned.

Eva Garriott is another employee of the Dorchester County Library and had worked at the George H. Seago Jr. Branch for a number of years. She states that she is personally aware of a custodian who cleaned the building at night and often complained of the levitating books being used as literary projectiles. He claimed that it was not only individual books, but also on occasion entire rows of books that would float away from the shelves as if bundled between

two invisible arms. They would levitate away from the shelves and then drop onto the floor in a pile. Other times, they would be wiped from the shelves as if someone angrily swept them off. The custodian was apprehensive but eventually chose to ignore the incidents and complete his job.

One day, the library employees came in to find all the janitorial equipment lying around the library. Mop buckets were sitting in the open, and a mop was lying on the carpeted floor. The janitor himself was nowhere to be found. Concerned for the safety of the missing custodian, they began a search for him. When they were finally able to reach the janitor by phone, he advised them that he resigned and was not ever coming back. The supervisor could tell by the custodian's voice that he was shaken, but he would not elaborate on any details of the event that had precipitated his prompt resignation, although he did state he was quitting because the place was haunted and he could no longer work there.

The older building that houses the Timrod Library dates back to the early 1900s, whereas the George H. Seago Jr. Branch was built in the 1970s. Much like the Summerville resident who suggested the Timrod Library as a potential subject, one might be tempted to believe that the older building would contain a ghostly inhabitant or two. That is obviously not the case. Ms. Lodge states that it is not the building that houses the George H. Seago Jr. Branch that holds the key to the haunting. She advises that it is the location. According to what she has been told, the Trolley Road branch of the Dorchester County Library was built on the grounds of what was once a Confederate military hospital during the Civil War. Many Confederate soldiers died there from the wounds they received in battle. Many more suffered the horrors of the primitive battlefield surgical techniques of the time. Hundreds died agonizing deaths, while those who survived bore the scars for the rest of their lives. Perhaps the bloody arm the one librarian encountered was a residual remnant of one of those battlefield surgeries.

As they say, "Don't judge a book by its cover."

Perhaps Henry Timrod himself best memorializes the many lives lost to the Confederate cause:

> *Sleep sweetly in your humble graves,*
> *Sleep, martyrs of a fallen cause!—*
> *Though yet no marble column craves*
> *The pilgrim here to pause.*

In seeds of laurels in the earth,
The garlands of your fame are sown;
And, somewhere, waiting for its birth,
The shaft is in the stone.

Meanwhile, your sisters for the years
Which hold in trust your storied tombs,
Bring all they now can give you—tears,
And these memorial blooms.

Small tributes, but your shades will smile
As proudly on these wreaths to-day
As when some cannon-moulded pile
Shall overlook this Bay.

Stoop, angels, hither from the skies!
There is no holier spot of ground,
Than where valor defeated lies
By mourning beauty crowned.

Perhaps someday the war will end for the restless soldiers of the George H. Seago Jr. Library.

The Quackenbush–List House: The Praying Soldier

This story comes from Heyward Hutson, president of the Summerville Preservation Society, who had the opportunity to interview the Collins family firsthand about their encounter as he was writing a series of articles for the *Summerville Journal-Scene*.

At the corner of South Main Street and Joyce Lane lies a home known as the Quackenbush-List House. This house has been home to many families during its existence and was acquired by the Collins family in 1973.

Sometime after moving in, the Collins family began to realize that they were not the only residents there. One night, Margaret Collins got up to get a glass of water. After doing so, she started back down the long, dimly lit hallway toward the bedroom. She began to get an uneasy feeling. That feeling quickly turned into the unnerving feeling that she was not alone.

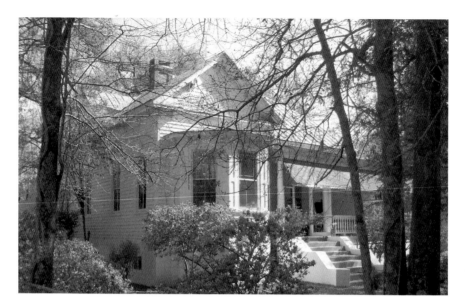

The Quackenbush-List House.

She felt a definite presence in the hallway with her. Overwhelmed by the thought, she ran back to her bed, dove in and threw the blankets over her head, much as a small, frightened child would to escape a visit from the imaginary boogeyman. Quite shaken by the feeling, she peered out from underneath the cave of safety she had created with her covers. She instantly was confronted with the deepest fear that every child who has hidden under the covers faces: she saw her boogeyman standing at the foot of her bed! Her boogeyman was not the product of her overactive imagination. He was right there before her eyes!

The man was tall and dark and appeared to be wearing a long, dark coat. The coat appeared to be part of a uniform. He also had huge hands with long fingers. With his right hand, he reached out to her. Margaret Collins released a scream that would have awakened the dead; that is, if the dead had not already been standing at the foot of her bed. The figure reacted by coiling back and receding into the floor, where he disappeared.

Mrs. Collins told her mother. The older woman also lived on the property and occupied the apartment above the garage. Her mother informed her that she, too, had encountered the ghost. She had endured his visits on two separate occasions but had kept silent for fear that her daughter and son-in-law would think she was crazy and have her committed to a psychiatric hospital.

When pressed further, Mrs. Collins's mother stated that on his first "visit," she had been awakened because her hand was extremely cold. In fact, it was actually freezing. As she woke, she realized that there was a man in a long, dark military coat in a kneeling position beside her bed, as if he were praying. He was holding her hand. As she became fully conscious, the specter simply vanished into the floor.

The second time, the same cold feeling awakened her. This time, she felt it brush across her stomach. Recognizing the feeling, she woke this time to find the man standing at the foot of her bed. As she reached for the light, he disappeared.

Mrs. Collins thought she had been the first and only one to encounter the ghost until she spoke with her mother. Now, it appeared that her mother had seen the spirit days before and had been the first to encounter it. They were both wrong.

Mrs. Collins recalled that three weeks earlier, her daughter had screamed out for her in the middle of the night because she had awoken to find a man in a long, dark coat standing at the foot of her bed. He also disappeared into the floor when she screamed for her mother. Margaret Collins had just dismissed it as a bad dream. Her own encounter validated her daughter's experience. Grandmother, mother and daughter had all experienced the same apparition.

Some time passed without any further incidents, until one night Mrs. Collins was in the bathroom washing her hair when her toy poodle began barking at something under the bed. The dog would viciously bark at whatever was under the bed and then back away. Frightened, she ran down the hall to the phone and called her husband at the newspaper where he was working. She was informed that he had left and was on the way home. She hung up and waited anxiously for her husband. Within a matter of minutes, she began to hear footsteps, as though someone were walking up and down the hall. She called the paper again and kept them on the line until her husband arrived home.

When the Collins family sold the house in 1983, a man came to inspect the old structure for termites. As he crawled out from beneath the house, he asked about the grave site underneath. They had no idea that there had been anything like that under the home. He informed them that there was what appeared to be a grave site and some sort of shrine marked by a stone. The Collins family completed the sale and moved three days later.

Sometime later, Bill Collins published a column on the experiences of his family. A subsequent family called him at the newspaper to inform him

that they, too, had seen the ghost in the dark uniform when they rented the house. Another subsequent owner stated that he had never encountered the ghost, but his children were frightened and had eerie feelings in their guest room—the same room where Margaret Collins had her encounters.

Ms. Michelle List, the current owner, states that she has also had experiences at the home. She states that immediately after moving in, her husband was skeptical about the story of the ghostly soldier. He began verbally expressing his skepticism to his wife, and as if in response to his negative comments, a ceiling fan turned itself on. Not dissuaded at this point, he continued to express his skepticism. A light switched on in response. Being an older home with an older electrical system, it takes some effort to flip the old light switch. The resonating click from the light switch ended the discussion.

In discussing the stories with Ms. List, she was quite surprised—actually, she was quite startled—by the information about the grave underneath the house. She had never heard this information before. She allowed me to investigate and actually accompanied me underneath the house. We found no grave but did discover a hole approximately seven feet long, three feet wide and four feet deep. Could this have been a hole left behind by someone exhuming a body? There was another family who owned the house between the Collins family and the List family, and if a body had been removed, it would have had to have happened then. Chances are good that this was not the case and the termite inspector was mistaken about what he saw. Nevertheless, there is indeed a large hole underneath the home.

Who could this apparition be, and why did it seem that he was praying? Perhaps the following story holds the key.

During the Civil War, the area where the home and the adjacent Rollings School of the Arts now stand was known as Red Hill. This was due to the red clay that the area was composed of. The area, at that time, housed a large regiment of Confederate soldiers and also included a hospital a few blocks away. The Confederate military hospital was located at the corner of what are now South Main Street and West Sixth South Street. One of the Confederate surgeons who served there was James A. Harold, MD. He was known for organizing Summerville's Home Guard after Federal troops took occupation of Charleston in February 1865. He asked General John Kotch for permission to form a guard to protect Summerville from raiders and have it declared a suburb of Charleston. When raiders attacked Summerville, Harold promptly shot the first one who questioned

the guard's authority. The other raiders fled, and there were no further raids on Summerville. After the war ended in April, Dr. Harold returned to being rector for St. Paul's Presbyterian Church.

During this time immediately after the Civil War, the area where the Quackenbush-List House is located housed a Union regiment of black soldiers. The Thirty-fifth United States Colored Troops, also known as the First North Carolina Colored Troops, was under the command of Colonel James Beecher. Colonel Beecher was brother to Henry Ward Beecher and Harriet Beecher Stowe, author of *Uncle Tom's Cabin*, both staunch abolitionists. Colonel Beecher was also a staunch abolitionist, and his wife, Frances, spent much time teaching the men of the unit to read and write.

Colonel Beecher, who was also an ordained priest, came to Communion at the former Confederate surgeon's church. Most believe that this was likely done to intimidate the reverend for having been a former Confederate surgeon. After all the regular parishioners had finished, the colonel approached and asked his former enemy if he could receive Communion. The former Confederate surgeon responded to the Union colonel by saying, "If you do truly repent of your sins and are in love and charity with your neighbors and intend to lead a new life, I have no right to exclude you. Approach and receive the sacrament." Colonel Beecher was shocked at the response. Humbled, he proceeded forward and did receive Communion. The two former enemies now stood face to face, bound by their common faith.

What is striking about this historical record is the fact that this man, Colonel James Beecher, was an ordained minister in command of a regiment of soldiers in the very location where the Collins family and others encountered the praying ghost a century later. Colonel Beecher prayed for many of his soldiers during his lifetime, so perhaps he, or another soldier he influenced, continues to do so at the Quackenbush-List House.

GUERIN'S PHARMACY: THE GHOSTS OF GUERIN'S

In 1871, Dr. Henry C. Guerin founded Guerin's Pharmacy. The former Confederate army major bought out Schweatman Drugstore, which had begun its Summerville operations during the Civil War. Dr. Guerin moved the operation across the street to South Main Street and what is now Richardson Avenue. Since that initial move across the street, the store has

not moved again. It has also never closed its doors. It is the oldest operating pharmacy in the state of South Carolina and continues to serve the needs of the citizens of Summerville and neighboring communities.

Only two families have ever owned Guerin's Pharmacy. Joseph A. Guerin inherited the store from his father, Dr. Henry C. Guerin. The current owner, Charlie Dunning, acquired it in 1975. Charlie Dunning's uncle, Herbert, had begun working for Joe Guerin in 1910, and Charlie Dunning himself began working for his uncle there in 1938. Mr. Dunning, at the age of twelve, started out at Guerin's Pharmacy by making deliveries on his bicycle.

Mr. Dunning states that he delivered packages all over Summerville, and for the most part it was fairly easy work, although sometimes he would be tasked with some difficult deliveries. One of his toughest, yet most memorable, was delivering ice cream cones in the scorching heat of a Summerville summer. He often tells the story of one customer, a grandmother, who lived a mile or more away from the store and would often order the ice cream cones to be delivered whenever her grandkids visited. "Ever tried to ride a bicycle and keep a half dozen ice cream cones from melting in the summer sun? Do you know how fast you have to pedal to do that?" he'd laugh. Obviously, he didn't. He was definitely not faster than the summer sun; inevitably, he would arrive with a melted and

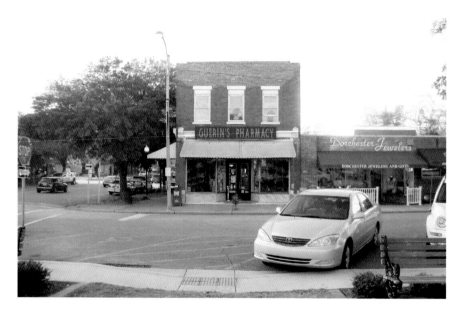

Guerin's Pharmacy.

38

dripping mess that was once ice cream cones and receive a tongue lashing from the customer. This complaint would later be repeated to his uncle, who would also receive an earful of the grandmother's wrath.

When Dr. Henry C. Guerin built the pharmacy, it was originally a simple wooden building. It was later bricked over in the early 1920s. During remodeling in later years, the Dunnings located writing on an upstairs wall in a room that is now the office of Robert Anderson, certified public accountant. The writing was done in white chalk by Joe Guerin, acknowledging the tragic sinking of the *Titanic* in 1912. It was a tragic moment that Joe Guerin felt compelled to record. The little store would continue to see many more such events, tragedies and wars throughout the years, long after Joe Guerin passed away. In fact, the little business was not immune to personal tragedy either. Robert Anderson, who now occupies the upstairs office mentioned earlier, states that his father suffered a cerebral hemorrhage and collapsed in the doorway to the pharmacy, where he died directly beneath the office his son now occupies.

The building has faced everything from a massive earthquake in 1886 to a devastating hurricane in 1989, yet through it all it continues to serve the needs of the people throughout the Lowcountry. The dedication of the people of Guerin's Pharmacy goes beyond that of the generic pharmacy chains that now seem to sit on every corner. In fact, the dedication of its employees transcends all boundaries—including death.

Barbara Dunning, Charlie Dunning's daughter, works in the back of the pharmacy filling the prescriptions of the customers, answering their inquiries and assisting them with their needs. On more than one occasion, she has returned to the back to find that she is not the only pharmacist tending to the customers' needs. More than once, she has returned to the back to observe a short, heavyset man going about his tasks. He walks around a corner, or behind some shelving, completely oblivious to the audience he has attracted. Once out of eyesight, he apparently vanishes.

When he first appeared, it was thought that there was an intruder in the store, but a thorough search of the store produced no such trespassing culprit. As subsequent appearances were made, it became apparent that something else was taking place. Apparently, a former pharmacist was so dedicated to his community that he continues to serve it in his afterlife. It is dedication like that that keeps the customers of Guerin's Pharmacy coming back.

And they do keep coming back.

Peggy Neal has been working at Guerin's Pharmacy for quite some time. She states that when she lived on nearby Doty Avenue, she would walk to

work daily, enter the store and prepare for her shift. She states that one day she entered the store, and as she was preparing for the day's events, she observed a woman standing at the counter. The woman looked a bit out of place, dressed in an older-style dress and wearing heels, but nonetheless, Peggy hurried past the woman and around the counter to assist her. As she got to the back of the counter and looked up, the woman was no longer there. Ms. Neal searched the store and could not find the customer. She was quite bothered by the fact that the customer may have left the store angry, feeling that service was too slow or inadequate.

The next day, Ms. Neal walked to work as usual and repeated her routine. As she was doing so, she looked up and saw the same woman from the previous day standing at the counter. Ms. Neal acknowledged her and hurried to a position behind the counter to assist her. She was happy to see that the customer had returned, and she was anxious to help her. As she moved to her position behind the counter, she lost sight of the lady momentarily. As she reached the position behind the counter, she looked up, only to realize that the woman had disappeared. Once again, she searched the store and even looked outside on the sidewalk, but the woman was gone. This was absolutely unbelievable! It was as if she had just vaporized. No one could move that fast!

The next day, Peggy Neal was determined to get to the bottom of things with this customer should she return to the store for a third consecutive visit. Once again, she began her routine, and once again she looked up to observe the woman standing at the counter. Ms. Neal was determined not to take her eyes off the lady or even blink if necessary. As she moved and watched the woman, she came to realize that she was wearing the same dress as the day before. In fact, it was the same dress as the first visit. The high-heel shoes were the clincher. They just seemed so out of place. Something was definitely not quite right with this woman.

Peggy Neal never took her eyes off the woman. As she rounded the counter to reach a position to assist the potential customer, something happened that the cashier would never forget.

The woman in heels did indeed vaporize into thin air. "It was as if she evaporated right in front of me," Peggy Neal states.

Apparently, customer service was far better than Ms. Neal first thought. This customer apparently thought it was worth *coming back* for.

There have been other instances of unexplainable events at Guerin's Pharmacy, such as the smell of cigar smoke in the early mornings or late evenings. The smell is there, yet there is never anyone around producing

it. There was also an incident with the sounds of a large, heavy object being dragged across the floor in the upstairs office area. This was heard by several people, including a visiting drug rep, according to accounts. The sounds continued until several people went upstairs to investigate. No one was located, but a large and fully packed trunk had managed to move itself across the floor of its own volition.

Guerin's Pharmacy has a unique warmth that cannot be described in words. To even attempt to do so would be doing the pharmacy a great injustice. It can only be experienced by walking in its front doors. In fact, the handles are worn through by the thousands of patrons it has served in its 140-year existence. Once you enter the location, you can feel that indescribable warmth created by decades of customer hospitality, southern charm and the love for the establishment. It is this warmth that transcends time itself, and it is what keeps people from everywhere—even death—coming back.

Dennis Ashley Architects: The Ghost in the Gray Business Suit

On South Main Street, located among the buildings that line Town Square, is the office of Dennis Ashley Architects. It is in a row of buildings once known as the Guerin Buildings. The buildings were purchased and renovated and now contain a multitude of businesses on both the upper and lower floors.

On May 11, 1965, B.E. Anderson, a certified public accountant, utilized the office now containing Dennis Ashley's office. According to accounts, the late Mr. Anderson was working on his books unusually late one evening and was all by himself in the office. All of a sudden, he felt an eerie presence and realized that he was no longer alone. He described it as a "personality" more than a presence. He slowly turned around, and there was a man in a gray suit. Mr. Anderson said that he could distinguish the features so well that he thought he might recognize the man. The apparition lasted a few seconds and faded away. Mr. Anderson left the building and went home.

Many folks claim that he never told a soul and that his encounter was left in a letter found after Anderson died. That was not the case, according to his son, Robert Anderson. Robert states that his no-nonsense father was a skeptic up until that evening and that it troubled him so much that he documented it in his business journal.

Some years later, another certified public accountant's office was located in the same area. This time, Converse A. "Pete" Chellis Jr. worked there in the

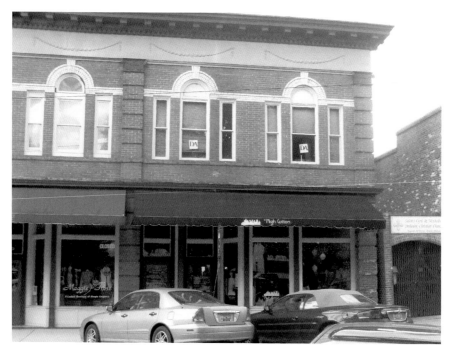

Dennis Ashley Architects.

upstairs office. One night, he was working late checking on the installation of some equipment there. He was at the far end of a long hallway and started back toward the entry door, which was at the top of the stairs leading down to the sidewalk. Mr. Chellis was startled by a man in a gray business suit standing in the hallway. The man was a stranger, and Mr. Chellis could not figure out what he was doing there since he knew the entry door was locked. The man disappeared, and Chellis reached the entry door only to find it locked and the man gone. Mr. Chellis went home, still pale and shaking from his encounter. He told his wife, who later recounted the event. She stated that Pete Chellis, like B.E. Anderson before him, was a serious person and did not believe in ghosts. She said that you could bank on it that if he saw a man in a gray business suit, such a man was there.

Mr. Chellis did not know of B.E. Anderson's encounter until much later. According to Anderson's son, Robert, Chellis perfectly described the same apparition Robert's father had seen many years earlier. He also said that Chellis told him something else that he had not confided in many others. He stated that the man in gray did not move out of his sight and disappear;

rather, the man looked directly at him, turned and then walked into the wall. That is why Chellis went home pale and shaking.

The offices had also once belonged to the town attorney, Legare Walker. His secretary, Doris Rump, had a fatal heart attack and died within the office. Some claim to hear her manual typewriter keys clicking at times, and others claim to smell her perfume.

Many claim to smell cigar smoke in the building; one lady became overwhelmed by it and actually had to leave the building. Dennis Ashley says that he has smelled both the cigar smoke and the perfume. He says that when the building contained a store named In High Cotton, the owner came in one morning and locked the front door. She then went in the back to work on inventory. The shop suddenly filled with an overwhelming cigar odor, which made her ill to the point of vomiting. She went back to the front and discovered that the door was still locked and she was alone.

An employee in the lower shop on the first floor says that she was once unpacking merchandise and heard someone behind her exclaim loudly, "Oh, I like that!" She turned around, and no one was there. She also says she has heard her name called when she is alone.

According to Robert Anderson, the building that contained the offices where these people worked sits on property that once contained a boardinghouse that burned to the ground in the late 1800s. He believes that the location is the reason for the encounters and not the actual office building.

Dennis Ashley says that he has never felt an ominous presence and has often talked out loud to the spirit as he worked late into the evening. He says that although he has never seen the ghost, he still tells him how much he loves the building. Apparently, it is something the two have in common.

This Whole House Tea Room, Antiques and Gift Shop: The Ghost That Stayed for Tea

At the corner of East Doty and South Magnolia Streets is a remarkable little cottage just across from the railroad tracks. The little cottage has stood on the corner since 1875 and has been home to many interesting businesses through the years. It is now the home of This Whole House, a quaint little tearoom and antique shop.

In 2002, Judy Thomas began This Whole House as an antique and gift shop. As a Valentine's Day gift in 2004, her husband, Mychael, had purchased

the little cottage and presented it to her with the instructions to make it her own and fulfill her dreams. She did just that and converted the little cottage into a very popular tearoom, a fitting business for historic Summerville.

Summerville has many claims to fame, but one of its best-kept secrets is its connection to tea farming and cultivation and the fact that it had the first commercial tea farm in the United States. Dr. Charles Upham Shepard created an experimental tea farm in 1889, located on land that was originally part of Newington Plantation. The tea farm eventually grew to six hundred acres as Dr. Shepard acquired neighboring properties.

The tea plantation known as Pinehurst was indeed the first place in the United States where tea was grown, cultivated, manufactured and refined for commercial use. At first, the cultivation was experimental, but eventually the tea was successfully marketed and reported to be of the highest quality. In his first year, Dr. Shepard produced only ninety-eight pounds of tea, but by 1899, he had increased production to thirty-five hundred pounds. With the attention it gathered by winning first place at the World's Fair in St. Louis, the demand increased, and Dr. Shepard was producing twelve thousand pounds by 1907.

The business continued into the 1940s. Accounts made in the book *Reflections of Dorchester County, South Carolina*, claim that the buildings and machinery were destroyed in 1919, but an experimental plot of eight acres was maintained by the Lipton Tea Company at the plantation for many years before being moved to Wadmalaw Island. It was marketed under the label "American Classic Tea." And it is still claimed as the only tea marketed in the United States that is native to this country.

Summerville was also the home of the Teapot Grocery. It was established in 1886 and served Summerville for sixty-eight years before closing in 1954. Apparently, it started at approximately the same time that Dr. Shepard started his tea farm, but the little grocery store endured much longer. The little store started with bag boys loading groceries in horse and buggies and lived to see the bag boys of later generations putting groceries in automobiles. Many of the older generation of Summerville residents have fond memories of shopping at the Teapot Grocery.

The creation of This Whole House Tea Room in Summerville was not only a wonderful addition to the businesses and restaurants of Summerville but also an acknowledgement of the accomplishments of its past tea history at Pinehurst Plantation and the memory of the Teapot Grocery.

Judy Thomas was extremely excited about the potential of her new business in such a quaint little cottage. Box after box of antiques, gifts

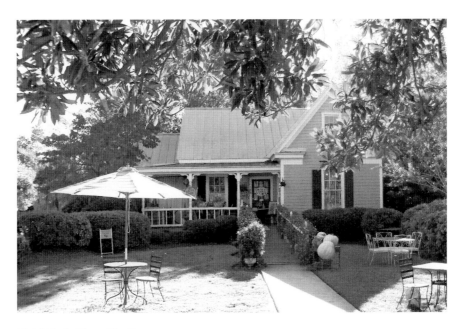

This Whole House Tea Room.

and crafts found their way into the location. The cups and saucers were unpacked, and the little cottage began to take shape. In the transition from cottage to tearoom, Judy Thomas's niece, Marsha Vega, had prepared a prayer to bless the family, their endeavors and the little cottage and business in hopes of a successful future, but during the typical chaos that ensues with every move, the prayer became misplaced.

Eventually, the days turned into weeks and the weeks into months, and it was now late June 2004. As the business opened, the missing prayer resurfaced in a group of papers one stormy day. As the family gathered around, Judy began to read the lengthy prayer aloud. The prayer began by asking for God's blessing on each of them and the relationships they had and the work they were doing.

Then the prayer's focus turned toward the business and the little cottage itself.

"I ask Father for Your hand of blessing upon this new business establishment," Mecia Brown, Judy's daughter, read.

I lay a spiritual axe to the root of any past generational curses that the enemy may have established here. I place a hedge of protection around

the parameters of this property, and I call forth and dispatch a legion of warring angels to stand guard day and night to watch over and protect it from any plans or schemes of the enemy.

She continued, "I pray for a spirit of peace to rest within the walls."

At that instant, as if in response to the words of the prayer, the front door of the quaint little cottage flew open and slammed against the wall. The startled group stared in surprise.

Just as quickly, the door violently slammed closed. In shock, the group stared at one another in disbelief. Had nature's storm created a natural phenomenon with uncanny timing, or did something truly diabolical get tired of listening to the prayer and decide to leave for more "comfortable" surroundings?

Eventually, the incident faded to the back of their minds as business matters engulfed them, and in the following days, the business began to get into a routine flow—sort of. It seems that as soon as everyone settled into a routine, the little cottage would throw a curve ball. It all started with the doorbell.

In the process of transitioning the cottage into a new business, Judy had asked her husband, Myke, to install a chime to let them know if customers were waiting out front. When he asked her what kind, she told him to get the cheapest he could find. He did, approximately seven dollars' worth, and that's what he installed. Now, on occasion, they would be surprised by the sound of the device playing to the tune of the Westminster Chimes. It was very beautiful, according to Judy, but the problem was that the product they had purchased was not designed to play that tune—or any tune for that matter. It was just a simple, cheap door chime. What made it even more disconcerting was the fact that it played on its own, usually when the tearoom was full of customers. Once again, this incident, like the front door incident, was chalked up to natural phenomenon—or at least Myke's improper wiring.

One Saturday, the little tearoom was extremely busy. The place had had a remarkable day, and excitement eventually gave way to exhaustion as the customers slowly dwindled and the tearoom closed for the evening. Exhausted, Judy placed the day's receipt tickets beside the cash register at checkout. It is usually standard procedure to count the receipt tickets to see what volume of business they had experienced, but frankly, everyone was tired and just wanted to close shop and go home.

The next day, Myke asked how many customers they had seen the day before. Judy of course responded that she had not counted the receipts the

night before because she had been tired. The question once again sparked her own curiosity, so she went to do the counting. Only two tickets were found where she had left a stack of them. That was impossible since they had served far more customers than that. Thus began the extensive search for the missing tickets.

Only Judy, Myke and one waitress had been there Saturday, and the same three were back preparing for Sunday brunch. Judy questioned both her husband and the waitress, and both were adamant that they had not only not touched the tickets but also had not seen them. Of course, this made matters worse for Judy, who began to second-guess herself. As she continued preparing for Sunday brunch, the thought of the tickets and their whereabouts began to consume her. Even though an hour had passed, she could not stop thinking about the tickets. She knew good and well exactly where she had placed them and knew she was not insane. She decided to start the search all over again. When she returned to the checkout area, all of the missing tickets were sitting neatly piled in the middle of the checkout. She knew that neither her husband nor the waitress had been capable of placing the tickets there for the simple fact that all of them had been working in proximity and none would have had an opportunity to do so. Unlike the door or the doorbell, the receipt tickets could not be explained.

That was just the first event of many yet to come that they would not be able to explain away.

Leslie Johnson rented the upstairs and had a collection of Polish pottery. One day, Ms. Johnson returned to the shop to discover a very large bowl of hers sitting on the ground where it had obviously been carefully placed. It would have had to have been intentionally placed there because had it fallen from the shelf where it had been sitting, the extremely fragile bowl would have been destroyed. Ms. Johnson placed the bowl back on the shelf and went back down the stairs, where she asked Judy about the unusual discovery. Judy informed her that no one had been upstairs at all that day. The curious issue was dismissed and forgotten as everyone went about their business. A little over an hour later, Ms. Johnson went back upstairs. The bowl was sitting neatly on the floor again. No one had been upstairs at all.

Two weeks later, a similar incident occurred with a large tea container in their dining room.

Myke had returned with a large number of groceries and discovered a large glass container sitting in the middle of the floor in the dining room. The container contained dry loose-leaf tea and was just sitting in a place

where there was no reason for it to be sitting. Upon inquiring about it, he confirmed what was already suspected—no one had moved the container.

Due to the shop's location, it is not unusual for things to be rattled from their resting places. After all, the little shop on Doty Street sits adjacent to the railroad tracks. As a matter of fact, the street name had even been changed from Railroad Avenue to Doty Street. The vibrations from the trains often shook items loose. That is not at all unusual. What is unusual is that these items are usually broken, chipped, shattered or generally annihilated. The problem was that the items they were finding were not broken or damaged in any way. Waitresses were beginning to find items moved and relocated around the tearoom. Everyone was running out of explanations for the events that seemed to be occurring with more regularity.

One morning, a waitress was busily working in the tearoom and turned to notice a foot and skirt swishing past the doorway inside the gift shop. She suspected that a customer had somehow gotten past her and went upstairs to look around. She quickly went up the stairs to assist the customer, only to find no one there. There was nowhere for anyone to go, and the waitress was certain that she had seen someone. Even though she could not locate anyone upstairs, she was unable to shake the feeling that she was not alone up there. The waitress's stay at the tearoom was not long after that. She located employment elsewhere.

On another morning, a young lady entered the tearoom. As she looked around at the collection of antiques and gifts, she asked if she would be able go upstairs. She was instructed that she could, and after some time, she descended the stairs and immediately asked Judy about the lady upstairs. Judy advised her that there was no one upstairs. The customer advised her that there was a woman upstairs and that the woman's name was Mary. Judy had no employees by that name. What they had been suspecting all along had now been confirmed. The little cottage had come furnished with a ghost.

This Whole House has since grown accustomed to its tearoom guest. Waitresses have learned to anticipate finding items moved and relocated. In fact, a visitor recently inquired about why a large knife was lying at the front door of the gift shop. When employees investigated, they did indeed discover a kitchen knife on the floor at the door where just moments earlier none had been.

The customer identified the ghost as Mary, but Judy and the others have given her the additional name Helen. This is the name of the mother of one of Judy's friends. This person seems to have a lasting impression on people

and seems to enjoy making her presence known, much like the tearoom ghost. Mary Helen continues to make her presence known as she sees fit. She is also not without her favorites in the tearoom.

One of the waitresses, Kate Hunter, seems to be a favorite target of Mary Helen. When Kate turns on the radio, you can rest assured that in a short time frame it will get turned off. Likewise, if Kate turns off the radio, it will inevitably turn itself on a short time later. Kate has also not only experienced the rearranged objects but also has the notoriety of being the only employee who has actually witnessed an item being moved. A plate actually levitated in front of her in the kitchen and sat itself down elsewhere.

The ghost also seems to have an attraction to Myke, Judy's husband. It also seems to have taken an interest in me during my visits to the tearoom in preparation for this story. For years, I have utilized recorders to interview witnesses. I have used an RCA digital recorder for quite some time now. When I spoke to the employees, I used that same recorder. In my interview, the recorder shut off three separate times. Undaunted, I made arrangements for a second interview two days later. As I was leaving, there was a large crash of dishes in the kitchen. Investigation revealed no broken dishes and no one there to have broken them. With a chuckle, I left.

When I returned days later, I had purchased a brand-new package of batteries. I installed them and began recording. Five minutes into taping, the recorder shut down. I laughed and acknowledged the event by saying, "Okay, Mary Helen, let me get this done." I never had another recording issue there or anywhere else. I can't say that it was truly an encounter with Mary Helen, but I cannot explain why it occurred then and there and has not occurred anywhere else before or since.

Investigation into the background of the location may shed a little light onto Mary Helen's fascination with men. The location is believed to have been a brothel that entertained many military men of both World War I and World War II and many other gentlemen as they passed in and out of Summerville by train. Perhaps Mary Helen ran her own business there.

Perhaps something other than tea was brewing in that little old cottage back then. We may never fully know, but for now, Mary Helen seems content with the Thomas family, and the Thomas family seems content with their ghost that stayed for tea.

MONTREAUX'S BAR AND GRILL: MONTREAUX'S MISCHIEVOUS MONTY

In a string of older buildings lining West Richardson Avenue is located Montreaux's Bar and Grill. This place is known for its great food and live music and has quickly become the place to be in Summerville when the sun goes down. According to the Charleston newspaper the *Post and Courier*, the bar

> *takes its name from both a town in Switzerland and a jazz festival that still takes place. In 1971 the Montreaux Casino burned down and Deep Purple wrote a commemorative song, "Smoke on the Water." Its guitar riff is considered one of the most famous in musical history.*

Decorated with framed albums and music memorabilia consistent with its name, Montreaux's is described as an "upscale sports bar" by one Internet source. Actually, Montreaux's Bar and Grill transcends that. It is the type of bar that is home to anyone—even "Monty."

This building, having been originally constructed circa 1860, has long had a reputation of being haunted through several generations of businesses located inside the two-story structure. Prior to becoming Montreaux's, the business was a bar named McGuire's Irish Pub. It seemed that the ghost at that time had an interest in protecting the customers who may have cavorted a wee bit too much with the bottled spirits there. More than once, customers complained of losing their keys, only to find them in strange locations in the bar the next day. Keys belonging to intoxicated customers would turn up in locations that only employees had access to. Those customers whose attitudes were less than pleasant sometimes never recovered their keys.

Prior to McGuire's Irish Pub, the location was the home of NAPA Auto Parts. Many times, a part would be set aside for a customer, and then when the customer arrived, the part would no longer be where it had been placed. A former employee states that he never saw anything, but he sure heard lots of things. Very reluctant to relate his experiences, he did simply state that there were always footsteps in locations where no one was walking. There were sounds of things being dragged around in locations no one had access to. He said he was glad to be in a new location.

One thing the former employee did clarify was the rumor that an employee had suffered a fatal heart attack at the former location. "That happened here," he said, referring to the new location. Even with a co-worker having died in the new location, this employee seemed far more comfortable at this

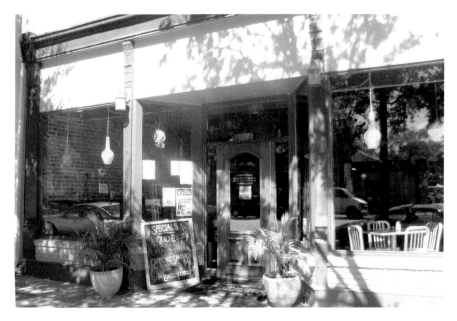

Montreaux's Bar and Grill. *Photo by Kayla Orr.*

place than he was even talking about the old NAPA Auto Parts, which is now home to Montreaux's Bar and Grill.

Prior to NAPA, the place had been a paint and hardware store, according to Charlie Dunning of Guerin's Pharmacy. That store had belonged to Gene Hutson and was known as Summerville Hardware. Before that, it had served as a dry goods store belonging to Chalmers Waring. The place was also once a boardinghouse and restaurant operated by a Miss Lucia prior to that.

Mr. Dunning started working for his uncle in 1938 just around the corner at the pharmacy. He was twelve years old at the time and made bicycle deliveries throughout the town. He says he recalls being told of the boardinghouse and restaurant known only as Miss Lucia's. His daughter, Barbara, remembers hearing that it was once part of "the red-light district."

Regardless of the past, the bizarre trend of paranormal poltergeist activity at the location continues with Montreaux's. When it first opened, Montreaux's employees in the grille section would clean the kitchen every night, only to return the next morning to find pots and pans moved around and rearranged. This continued for a brief time but eventually subsided.

Bartender Niki Schoffner says she was cleaning up behind the bar one night when a framed record album launched itself from the shelf it had been

sitting on. The album struck the bar and ricocheted back into the ice maker. The problem was that the album had a row of glasses and bottles directly in front of it. If it had simply fallen, it would have wiped out the entire row. None of the items had been touched, which meant that the album had to rise up and over the glasses and then launch toward the bar. Niki believes that the album was thrown at another bartender, Dave Watkins. The problem is that no one was there to throw it.

Montreaux's current general manager is Eric Price. Both he and Niki related the story of Eric's predecessor and the encounter he experienced. Apparently one night, this general manager was the last one in the building and had gone to the back office to count the money and place it in the safe. As he was doing so, he said things were extremely quiet. As he proceeded with the closing procedures, he realized things were too quiet—eerily quiet. All of a sudden, someone shouted his first name into his ear from a distance of less than a foot away. Obviously startled, he jumped up, only to realize that he was still alone in the office and the entire building. As fear overcame him, he threw the money into the safe, slammed the door and left the building as fast as he could.

Eric is now the general manager. He says that employees continue to hear their names called at night, just not as closely as the former general manager did.

On another night, once again at closing, a plastic caddy on the bar launched itself into the air from behind the bar. Eric witnessed the event and said there was no way humanly possible for the caddy to do what it did. The caddy usually contained cherries, napkins and the typical bar necessities and could not have simply blown off the bar. Even unloaded, it still had weight to it, and effort would be needed to launch the caddy.

The bar is equipped with surveillance cameras. Eric reviewed the tape and was startled at what he witnessed. What he describes as a white orb, and what Niki describes as more of a mist, descended down in a rapid swooping motion and struck the caddy, sending it flying. When asked about the tape, it was learned that it had been erased. The equipment has an automatic rewind feature and recycles the tape if it is not removed. In their excitement, they forgot to remove the tape, and human error caused it to be recorded over.

Although no one has claimed to have seen the ghost in human form, it continues to make its presence known periodically. Although no one knows who the ghost was, it is considered to be the most dedicated customer the old building has ever seen. The ghost has even been given the nickname "Monty."

If you're ever in the Summerville area, be sure to stop in and grab a burger or a beer. Just make sure you don't grab too many, or Montreaux's Monty may just grab your keys. If it does, remember to be nice to your bartender if you ever want to get them back.

The Price House Cottage Bed-and-Breakfast: Extended Stay

The Price House Cottage is the second-oldest residential dwelling in Summerville, dating back to circa 1812. Located on Sumter Street, it is now home to a bed-and-breakfast owned and operated by David Price. Since its construction, only six families have lived in the structure, with the majority of the earlier ones having been related by blood or marriage. This is quite remarkable considering the building will soon be two hundred years old.

David Price acquired the cottage in 1974 and began restorations and updates to the structure. For maintaining the historic quality and essence of the home while turning the location into a modern-day bed-and-breakfast, the restoration of the cottage received the Preservation Award from the Summerville Preservation Society.

Many guests comment that "no detail has been overlooked" in maintaining the charm of old Summerville. The antique furniture, four-post canopied bed and exacting detail in restoration transport visitors to a time when Summerville was considered one of the top locations in this country to visit, vacation and breathe in the aroma of the pines, which were considered to have medicinal properties. Many people fall in love with the location once they enter it. After spending time there, one becomes overwhelmed with the desire to stay and perhaps extend the visit indefinitely. Apparently, that is the case with one such couple at the Price House Cottage.

Immediately after they moved into the location in 1974, strange and unexplainable things began to happen to the Price family and their guests. On the very first night, the Price family was awakened by the sound of running water. As they began to investigate, they found the source of the problem. The faucets in the home had been inexplicably turned on—all of them. Issues with the faucets continued periodically.

Then, two weeks later, the grandfather clock began to have issues.

The family began to realize that the grandfather clock would stop every night approximately ten minutes after everyone went to bed. The

The Price House Cottage bed-and-breakfast.

clock would work fine in the daytime, but at night it would stop as soon as everyone went to their rooms and climbed into their beds. This puzzled the Price family, but eventually the issue with the grandfather clock became symbolic. It seemed that during the day, life went on. Things went as expected, and everything was business as usual. At night, it was a completely different matter. As soon as the clock stopped, time stopped as well. The past seemed to merge with the present.

One night, as the family was still moving in, a guest had fallen asleep on the sofa in the living room, exhausted from the move. During the night, she was awakened by the sound of heavy breathing directly beside her. The sound obviously startled her, but what had initially been surprise quickly turned to fear when she realized that no one was there.

Another night, the Prices had guests over. Things were going well until the entire group's attention was diverted to a window in the room. That one window had a single pane fog up before their eyes, as if someone had just breathed a warm breath on it. As they watched in astonishment, the pane cleared.

Then another pane fogged up.

As the condensation cleared, another would fog up. Then another would fog as soon as the last cleared. It was as if someone were deliberately breathing on each pane. The crowd was mesmerized by the event until the group jointly realized that no one was on either side of the glass.

The pattern of events seemed to increase in the passing weeks. Eventually, footsteps could be heard pacing the floors. Cold spots could be felt. Family members were beginning to be bumped or touched by an unseen presence.

Things began to disappear from one location and then appear in another. One such incident occurred when David Price's daughter was home from college. She owned a very special ruby ring that her mother had given her as a gift on her sixteenth birthday. The ring turned up missing overnight. An extensive search was conducted throughout the main house, the cottage and the grounds. The ring was nowhere to be found. The young woman and her family continued to search until it was time for her to return to college. Still, the ring was never found—until two years later.

One day, David Price was cleaning in his library when he picked up a large stack of books and began sorting through them. At the very bottom of the stack was a Roget's Thesaurus that had something inside it. When he investigated the lump, he discovered the missing ring. To this day, no one can explain how the ring ended up in that book.

The Prices became used to the events of the home. It seemed that more of the guests were experiencing encounters than the Price family. In fact, a mother and daughter were dining when they claimed to have observed a ghostly couple. The guests questioned the Prices and became slightly unnerved when they were informed that no one else had been in the dining room with them and the place was considered to be haunted.

Another guest complained of having closed the plantation blinds the night before so he could sleep in the following morning. As the sun rose, he was awakened by sunlight beaming directly into his face. As he sat up and cleared his eyes, he became keenly aware that the plantation blinds were open. In fact, every single plantation blind in the house was open, and he had been the only occupant inside the locked cottage.

David Price had been told by the previous owners that the place was haunted by two ghosts, a man and a woman. The prior owners claimed to have seen them and believed that they were the spirits of previous owners who chose to stay. Initially, he had dismissed the idea, but now David Price was beginning to realize there might be some merit to the information that he had originally passed off as the previous owners' embellishment.

Prior to the residence belonging to the Price family, it had been owned by Major John R. Middlebrook and his wife. They had purchased the location in 1970, and she reported seeing ghosts at the location. In a 1973 newspaper article in the *Summerville Scene* regarding their restoration efforts in the home, she reported seeing a male apparition. When describing the ghostly occupant to their neighbors, the neighbors shared their suspicions of who the spirit might be. The Middlebrooks were the ones who advised David Price of the haunting.

In 1925, Ms. Margorie Mullins of Franklin, Pennsylvania, married William Leisenring, and as a wedding gift, she received the house. They owned the home for many years and utilized it as a winter vacation home. After Mr. Leisenring passed away, his widow moved into it permanently and remained there until she sold it to the Middlebrooks in 1970. For forty-five years, Margorie Leisenring had owned the home she had received as a matrimonial gift. For many years, she and her husband spent their lives together there, building memories until they became as much a part of the home as the boards, bricks and nails that held it together. It was too much for her to give up in life. First, she lost her beloved husband, and now she lost their home. In fact, she died just three short years after giving up the home. Her love for her husband and her home knew no boundaries, and perhaps even death was not an obstruction.

The cottage is available for individual booking, and David Price prides himself on this fact. He never crowds the location by overbooking guests. This allows a couple the opportunity to enjoy the tranquility and peace of the cottage without interference from other couples. He does not, however, guarantee that you won't encounter one particular couple at the cottage who have apparently booked themselves for a very lengthy extended stay.

SHEEP ISLAND ROAD: THE SUMMERVILLE LIGHT

Ever since man invented the train, there has always been a connection between railroad accidents and disasters and the paranormal. Often, a location of such a disaster will develop a paranormal phenomenon. These paranormal oddities manifest themselves in the form of balls of light and are referred to as "spooklights," or simply "lights."

The lights appear in locations such as Paulding, Michigan, Surrency, Georgia, Gurdon, Arkansas and Wilmington, North Carolina, to name

just a few. In fact, President Grover Cleveland had an encounter with the Wilmington light in 1894 while traveling by presidential train. This light is commonly known as the Maco Light and is named after the station where it is located. It is said to have come into existence after the tragic death of a conductor named Joe Baldwin in 1867.

Summerville, South Carolina, has its own spooklight. Between Highway 17A and Highway 176 is what remains of a cut-through road known as Sheep Island Road. It is also unofficially known as Summerville Light Road, or simply Light Road. This road, or the approximately five-mile-long dirt section of it, is the location of Summerville's most famous—or infamous—ghost tale.

In the 1800s, Sheep Island Road was not a deserted dirt road but an area where train tracks existed and ran into the growing town of Summerville. One of the local train's conductors had a very faithful wife who would meet him in that area every night. She would stand beside the tracks, lantern in hand, and wait for the train's approach. Upon seeing the lantern, the train would make a special stop just to let him off to join her. The couple would then walk home arm in arm every night.

Sheep Island Road, also known as Summerville Light Road.

One night, the train ran behind schedule. The anxious wife waited and waited, and as more time passed, she grew greatly concerned. Finally, she saw the light of the train in the distance. She raised her lantern high and frantically swung it back and forth. The train finally slowed to a stop, and she ran to the engine. The engineer had a somber look upon his face beneath the lantern's glow. As the other workers gathered around, they informed her that there had been an accident. Her husband had lost his grip, slipped from the train and had been run over. The wife screamed in horror and disbelief and demanded to see the body. The workers had to physically restrain her as the emotional engineer advised her that it would be best if she did not. He told her that when her husband fell under the train, he had been decapitated by the wheels. The wife screamed at the horrifying news and fainted. Some crew members remained with her as the train continued into town. A wagon was sent back, and the traumatized woman was placed in the back and transported home. Once there, she had to be carried inside. Friends and family could do very little to console the traumatized widow. The town physician and even the couple's pastor were unable to help the grieving woman.

The wife never recovered from the shock and never came to grips with the harsh reality that her husband was not coming home. Eventually, she began to take her lantern and walk along the tracks every night to greet her husband. Initially, the train would stop out of courtesy and compassion, but eventually it became too painful for the crew to have to convince her every night that her husband was dead.

After awhile, the train would just pass her and continue on into Summerville as she frantically waved her lantern for it to stop.

Eventually, the old widow died, but her dedication and love for her husband never did. Often times, the train would see the light, only to get close enough to realize no on was there. Eventually, the train stopped traveling the tracks and they were removed, but the conductor's wife's nightly visits continue to this day. You can still see the light from her lantern as she walks the road where the tracks once ran, waiting for her husband's return.

Many folks claim to have encountered the eerie lights of Sheep Island Road, including Sandra Baxley, a local reporter, who documented her experience in the *News and Courier* in 1970. The light sent her and her traveling companion into hysterics before it disappeared. Many others have reported their encounters in local newspapers for decades, and still others have taken to the Internet to tell of their experiences. Some claim that the light has produced dents and scratches on their vehicles, while others claim their vehicles stall. Some have reported interference with electrical

equipment, causing it to shut down, while others claim the light causes metal objects to heat up to an uncomfortable temperature, including jewelry and even the rivets on jeans.

This area, now blocked off from travel and posted with trespass signs, was once a favorite parking spot for young men to take their dates for a little secluded romance. More often than not, the young couples encountered more than they had bargained for. Many a car from many eras has raced along that road to escape the light. In fact, I know of one young rookie deputy in the early 1980s who had an encounter with the light and left the area very quickly—backward.

In 1986, I was a young rookie deputy fresh out of the academy and eager to save the world. I was assigned to the South District of Berkeley County, an area that included Sheep Island Road.

One squad meeting, our sergeant, Johnny Richardson, was giving assignments. As we were departing for our 11:00 p.m. to 7:00 a.m. shift, Johnny stopped me and told me that I needed to patrol back along Sheep Island Road because the sheriff's office had been getting complaints of teens partying in the area. He further advised me not to stay too long in one area, not to flash any lights and not to go too far down the dusty old dirt road because I would not be able to turn around if the light chased me.

"Light?" I asked.

"Don't tell me you have never heard of the Summerville Light," he responded.

I have heard of many tales, but frankly, that bit of Lowcountry lore was not one filed away in my cranial library. He proceeded to tell me the story I have just retold.

After preliminary preparation for a long night shift, I gassed up the old Ford Crown Victoria cruiser and headed out. I made my nightly stop at the convenience store and grabbed a cup of coffee (no doughnut) and headed for Sheep Island Road.

Sheep Island Road has a long paved portion that passes over Interstate 26. There were concerns that the partying would get too carried away, and the participants would decide to start throwing objects off the overpass and down on the interstate for fun.

I patrolled along the paved portion as instructed. Johnny had told me to not, under any circumstances, go too far beyond the pavement or flash my headlights. He said a favorite trick of the locals was to flash the headlights three times off and on, wait a few seconds and then flash them again. Then they would turn the car around and wait.

"Why?" I asked.

"When the light comes, it comes slowly, but the closer it gets, the faster it gets. When it gets close, folks take off and run like hell in their cars. That's why you turn around. If you don't, she will get you."

I just laughed, but now I found myself at the end of the pavement. My front wheels dropped off onto the dirt. Very slowly, my back tires did the same. I slowly crept a few hundred yards down the road and put the car in park. Can you guess what the young deputy in his starched uniform and shiny new badge did?

Yep, I turned off my lights.

Then I turned them on again.

Then back off.

Then back on.

Back off—wait—back on and then off.

I had done everything Sarge had told me not to do, except turn my car around. Sure enough, a red light began to glow down the road. As it got closer, it seemed to move faster. It turned white.

I laughed and slowly opened my door. I knew beyond a doubt that Johnny was trying to scare me. He had told me the story, left way ahead of me and waited on me to show up. He knew I was a rookie, and he knew how I would react. All he had to do was wait on the flashing headlights, spook me with his flashlight and watch me run off in a hurry. He and the rest of the squad would have a good laugh at my expense.

"Not tonight, Sarge," I mumbled under my breath.

I figured the red light I initially saw was Johnny stepping on his brakes as he exited his cruiser. I also imagined that the white light that was now coming toward me was the light from his big metal Maglite flashlight. As the light approached, I quietly slipped out of my cruiser. As a safety feature, our interior lights had been disabled to allow such tactical deployment. It was designed to keep us from being illuminated as we got out of our vehicles on calls. At this point, I was more concerned with not being caught by another good guy than I was being shot by a bad guy. I slipped quietly around the rear of the car and over to the shoulder. I then crossed the ditch and began to walk slowly toward the light in a flanking maneuver. I had planned to pass the light, come in behind Johnny and use my own flashlight to scare him. I would be between Johnny and his car, and when he saw my light and panicked, Sarge would have to flee Light Road on foot. I was going to use my sergeant's own joke against him! I snickered to myself at my ingenious plan.

Unfortunately, it did not work.

Legends

As I approached the light, I came to within about three car lengths directly parallel to it. I immediately realized that there was nothing holding the light! It was now an eerie greenish color, and it illuminated the road in a green haze. Johnny was not there. No one was there. As I felt my knees get weak, the light immediately shot straight up about forty feet in the air and darted off into the woods. The smart rookie had outsmarted himself!

I screamed like a schoolgirl, turned, started to run and fell face-first in the ditch. In a move that would have made any action hero envious, I continued moving forward on all fours, then pushed myself up to two feet and made it to the cruiser. As I cranked it up, I realized Johnny had been right, not only about the light, but also about the inability to turn around. I backed out as quickly as I could. I was so thankful that the academy had taught me how to back up rapidly and for long distances. As soon as I hit the pavement, I spun the car around, threw it in drive and was outta there!

I went straight home. I had to change uniforms before I got a call and someone saw me in the shape I was in. As I walked in, my wife asked me what happened. After I used the house phone to let dispatch know where I was going to be for about twenty minutes, I told her. She laughed and said I was crazy. She did not believe me, and at that point, I was not sure I believed myself. I jumped in the shower and washed off the large portion of Sheep Island Road I had brought home with me. I swapped uniforms and cleaned the mud out of the car while waiting on calls. I never told anyone on that shift what had happened.

Back home, the disbelief continued. That weekend, I took my wife's brother, who was in the navy, and a friend who was in the coast guard out to Sheep Island Road. Both did not believe me. I did the same thing, just as Johnny told me, and once again I deliberately did not turn around. Sure enough, the light came so close that it lit the interior of the car green. It was the size of a basketball and hung suspended in midair. As I listened to two grown men whimper, I was glad that the seats in the cruiser were vinyl, and I prayed that none of us would inadvertently test their waterproof capabilities. The light stopped about a car's length away and burst into several hundred firefly-sized lights that dissipated. We all started breathing again and went home. I never doubted Johnny ever again, and those two never doubted me again.

Many years later, I was a lot less frightened of things. Twenty years of law enforcement make you a little less jumpy. By this time, I had retired from law enforcement. I missed investigations and doing research, so I joined a Summerville-based paranormal group and had started doing some research for them.

Local artist Suzanne McConnell's artistic interpretation of my encounter with the Summerville Light.

Legends

I had learned that Sheep Island Road had not been a passenger train line as the group had been told. It had, however, been a tramline, and the tram was used in logging operations to haul felled trees into Summerville for use in creating lumber to build the town. In fact, the area is owned by Westvaco Forestry, and its offices are a few miles down Highway 17A adjacent to a subdivision called Tramway (another indicator that the information was correct). I was not able to document any deaths along the tramline, but that does not mean there were none.

One thing of extreme interest to the group that I did find involved signal lanterns. I learned that the signal used at that time to make a train move forward was to swing a lantern up and down in an arc. A person would swing the lantern out straight directly in front of him up to his shoulders and back down to his knees. From a distance, this looks like a white light flashing off and on—just like headlights flashing. I also learned that red lanterns were used to make trains stop, and green lanterns were used to advise a train to travel slowly. All three of the colors have been attributed to the Summerville Light. I saw all three colors on the two nights as it approached me.

The group planned an investigation of Sheep Island Road, and I went with them for a rematch with the light. In order to keep vehicles off the road, the entrance had been blocked by a mound of dirt. Farther down, the road was impassable by vehicle due to large amounts of water. We all entered on foot.

Pretty soon, a light began to glow at the end of the road. Cameras began flashing, and videos started. I spoke up and said, "Who is going down the road to see what it is?" I got no response. "Who is going with me?" Finally, I got three volunteers—my friend Alessa, a kid on crutches and an old lady half dead with emphysema. We started out together, but I am the only one who completed the five-mile trek there and the five miles back. When I reported it was headlights, I was met with snarls and growls. I had debunked their hunt.

At the next meeting, I was preoccupied and did not attend. In my absence, I was voted out of their group. They were extremely upset that I had debunked their investigation while still maintaining my own claims of a past encounter. A friend who was in attendance told me there was an equal mixture of jealousy and fury! I received an e-mail advising me of their decision and instructing me not to come back. I still laugh about that to this day.

It is amazing how twenty years in the field of law enforcement had changed the rookie from an easily frightened Barney Fife to a seasoned and cynical Dirty Harry who would walk the entire length of the road and back,

in the dark, armed only with a flashlight and a cellphone. I also know that what I encountered back in 1986 was not what I encountered with that group. I cannot say that what I encountered on Sheep Island Road in the mid-'80s was the ghost of the conductor's wife, but it is definitely something I cannot explain over twenty-five years later.

The Summerville National Guard Armory: Permanent Duty Station

Built in 1958, the Summerville Armory has seen countless National Guard soldiers pass through its doors as they are trained and deployed. Considered home to one particular National Guard detachment, it is also home to a soldier who seems to have made it a permanent duty station. To quote the facility manager James Boyd, from a newspaper article several years ago, "This place is haunted as heck."

Many National Guard personnel have experienced events that they cannot readily explain. Most hear the sounds of footsteps in the drill hall, usually after 11:00 p.m. Sometimes the footsteps are accompanied by voices. Quite a number of people have reported hearing someone talking while they were alone in the building or in separate areas, away from others. It seems that when someone is separated and alone, he is more susceptible and vulnerable. In fact, one young soldier entered the building early one morning, only to be driven out by the eerie sounds of footsteps and voices inside a completely empty building. She quickly left the building and waited in her vehicle out in the parking lot until other personnel arrived. She was visibly shaken and distraught by her encounter and refused to ever be alone in the building again.

Another soldier reported that he was walking into a little hallway when an aluminum baseball bat was launched from an open office. It had been leaning against a wall in a corner earlier, but now someone had turned it into a metal projectile. The soldier, startled, rushed into the room to confront his would-be assailant, only to find the office empty. The bat had apparently crossed the room and exited the door of its own volition.

Another reported encounter involved a jail trustee who was assigned to clean the facilities. He had cleaned the location on many other occasions, but this time proved to be quite a different experience for the fellow. He stated that as he was in the men's shower area, the bathroom stall doors began to swing open and closed on their own, and the temperature in the room

The Summerville National Guard Armory.

began to drop. There was no breeze to cause the changes. Instantly, the man felt the presence of someone else in the shower room with him. Frightened, he dropped his mop, ran from the area and reported his experience. It was reported that he informed his supervisors that he wanted to go back to jail rather than reenter the shower area. He never returned to the facility.

Many people believe that the place is haunted by a soldier who killed himself in the facility. He was distraught at having learned that his wife had left him, and he took his own life in the shower in the same restroom where the jail trustee had his experience. He shot himself in the shower and died on the tile floor—the very floor the trustee had been cleaning.

In 1998, I was fortunate enough to be asked by Alkinoos "Ike" Katsilianos to work with his group, Darkwater Paranormal Investigations, in investigating the armory. Having had previous experience with surveillance equipment, I was asked to serve as a technical expert with their equipment. This was considered to be a training exercise for his group, and he also had Nick Smith, a reporter for the *City Paper*, and Jonathan Stout, a photographer, along to do an article on the group.

Ike's group had confirmed the report of the suicide at the location, and in fact, I located the indentations where the ceramic tile had been struck and damaged by the fatal round ricocheting in the shower before entering the

ceiling. I also set up cameras and equipment in the office area where the bat had been tossed and set up several cameras in the shower area. The investigation lasted for several hours, and in the end nothing was captured on surveillance cameras other than orbs created by the investigators as they walked through the dusty place and the cameras reflecting the airborne particles.

One theory that is widely accepted in the paranormal world is that ghosts generate an electromagnetic field and can be detected using an EMF (electromagnetic) detector. I was assisting Chris Gordon and Linda Doty in taking readings when Chris and I ventured off into the locker room. There, we picked up a very high reading, which we eventually determined to have been created by the refrigerator in the kitchen located on the other side of the wall where the EMF hit was discovered. It was not a ghost by any means.

A habit that I had gotten into as a law enforcement detective many years earlier was to carry around a recorder and let it run as I worked a crime scene. I would often refer back to it later when making case notes. Many people often asked me why I mumbled to myself on scenes, and I would have to explain. This night was no exception, and a little digital recorder recorded our conversation as we talked about the EMF reading in the locker room.

Another investigative technique of the paranormal trade is the recording of EVPs, or electronic voice phenomena. An investigator will usually conduct an interview with a recording device active. The investigator will generally ask questions and pause to allow a response. When played back, the recorder sometimes picks up disembodied voices that no one hears in the interview. Often times, these voices respond to the question asked by the interviewer. That is the general concept.

For the record, I have always been quite skeptical of EVPs. If an entity such as the one alleged to be at this location can speak loud enough for numerous soldiers to hear, then it does not need a digital recorder or other device for it to whisper into. There is also the visual and audible situation that occurs with the human brain, which I lump into one group referred to as "Matrixing." If you ask a question, your brain expects a response. It will begin listening for identifiable words. What may be a simple rustling of one's clothing might later be interpreted as a specter's audible response. It is the same thing your brain does with clouds when it sees animals. Your brain looks at a cloud, and your mind sees a bunny. Your ears hear a sound, and your mind works to interpret it as words.

In fact, I did not believe in EVPs at all until this particular investigation. On the recorder I was using when conversing with Chris, there is clearly a third voice talking over us as we discuss the electromagnetic reading. There

is no explaining the voice. It is simply there. It was on a recorder in my possession used for something other than EVPs, yet this one found its way into our discussion. I do not understand what is being said, but it is a voice—a third voice in a room occupied by just two men. With Matrixing, you hear words and your brain makes sense out of nonsense. This was definitely a human voice talking over our conversation.

There is also an issue with a picture taken by Jonathan Stout that made the article. About a year after the article came out, a person was reading a framed copy of it in my office.

"Who is this in the background?" she asked.

"That's Ike," I responded.

"No, *behind* Ike."

I looked and for the first time realized that there was the dark silhouette of a man behind Ike. This controversial picture has led to much debate. Neither Darkwater Paranormal Investigations nor I took the photograph, so we do not know precisely at what point during the investigation it was taken. The photographer, Jonathan Stout, does not recall anyone else in the area. Some believe it is the apparition of a deceased soldier, while others have claimed it was Darkwater's investigator Chris Gordon. Chris was with me the majority of the time, so that makes it rather difficult to prove. Also, it appears that

The controversial image taken during the investigation by Darkwater Paranormal Investigations. *Photo by Jonathan Stout.*

the figure was wearing boots and BDU camouflage pants, whereas Chris was wearing shoes and jeans, as evidenced in other photographs taken that night. Trying to lighten the picture does not help. The figure is actually facing outside, and identification is not possible. Was it a living member of the National Guard in that area at that time or perhaps something else?

Jonathan Stout has been gracious enough to allow reproduction of the photo as it appeared in the article. I make no claims to refute or validate the silhouetted figure as a ghost. As with all things paranormal, it is left to the viewer's interpretation. To me, the photograph, like the EVP, is another one of the unsolved and unexplained events associated with the Summerville National Guard Armory.

THE SUMMERVILLE CEMETERY AND MAUSOLEUM: GIFTS TO A CRYING CHILD

Many cemeteries and graveyards throughout the world are believed to be haunted. This country is no exception, and the South is perhaps the worst offender. With large oak trees draped in Spanish moss, the sounds of crows cawing and owls hooting in their branches and the scurrying of unseen creatures among the tombstones, southern cemeteries seems like such fitting places for ghosts.

Also, there is just something inherently "spooky" about a place where the bodies of the deceased are laid to rest. Perhaps this is why these locations have become the most likely places for ghostly encounters. Summerville is not without its own haunted cemetery.

Just off Boone Hill Road, in the vicinity of Summerville High School, lies the Summerville Cemetery and Mausoleum. This location is more often referred to as Parks Cemetery since it is owned and controlled by the Parks Funeral Home and has been for quite some time now.

According to information provided by Parks Funeral Home, the cemetery was founded in 1941, and the Mausoleum was added in 1984. It is a vast and sprawling cemetery that gives the illusion of seeming to go on for miles. Row after row of tombstones, a mixture of both flat- and standing-type designs, give any visitor an overwhelming sense of the fragility of life and the mortality of the human species. Immediately, it becomes quite apparent that many generations of Lowcountry residents have been laid to rest in this peaceful location. They have found eternal slumber under the giant oaks and crepe myrtles and are now at peace—except for one.

Legends

The Summerville Cemetery, also known as Parks Cemetery. *Photo by Kayla Orr.*

On many occasions, people in the neighboring baseball field and many more visiting their deceased loved ones have claimed to have had their activities interrupted by the distant sound of a crying child. As they continue their baseball games or their vigils of respect and reflection, the crying becomes louder and stronger. It eventually reaches the point that they feel they need to investigate. Many persons have claimed to have wandered the vast cemetery searching and searching for the crying child. They all claim to end up at the same location—the tiny grave of an infant girl.

Upon reaching the grave, the crying subsides. Many of these folks, upon locating the grave, feel inspired to leave something for the child and claim that the powerful feeling subsides when they do. Many others have fought the urge and left but feel overwhelmed by the feeling. They cannot shake the feeling until they return with a gift for the child. They often stop at a convenience store, make a small purchase and return to place their gift on the child's grave. It is not unusual to find the tiny little grave adorned with a multitude of flowers, coins, small stuffed animals, pinwheels and tiny little knickknacks and whatnots.

There are many claims and stories about who this crying child is and why the crying occurs. There are also computer websites that name the child and the date of her death as 2002. On these sites, there are claims that this child was violently raped and murdered by her father. With just a little research into the history of this child's name and death, no evidence is located in local archives to support such a horrendous fate. In checking with Parks Funeral Home itself, no such horrible fate is associated with the child. The fact is that this particular child was a two-month-old infant who died two days after Christmas 2002. No violent crime, just a tragic death. For that particular reason, the name is withheld here in this story. To lose a child is tragic. To lose your infant child two days after Christmas is horrendous. To have strangers labeling your child a wandering and restless spirit would be unbearable. Quite simply, I am a parent and, as a parent, will not subject another parent to continued suffering by naming her child as the ghost of this graveyard.

I was once told that not all ghosts are of the deceased. Perhaps the crying is not of the child but of the parents of the child lamenting over their loss. Perhaps the crying is from siblings mourning the loss of the sister they never knew. Pain and suffering are powerful emotions.

It is not my intent to draw unnecessary attention to a location where respect and reverence should govern visitors' actions. The reason I have placed this story in this book is because of the simple fact that it has become a part of Summerville legend. No one knows when this legend originated or the true facts behind what witnesses claim to experience. Perhaps it is the simple fact that this infant died at Christmas that draws so many to leave gifts for her. It is my hope that the family will find some solace in the smalls gifts, knowing that Summerville has come to eternally love this child they barely got to know.

II
LORE

THE UNUSUAL, THE BIZARRE
AND THE UNEXPLAINED

THE ANGEL AND THE EARTHQUAKE

At about 9:45 p.m. on the night of August 31, 1886, Summerville stationmaster Frank Doar received word that the train inbound to Summerville had just passed the Jedburg station. He settled back in his chair to await its arrival on that peaceful night. Everything was unusually quiet in the little town of Summerville. The evenings were still muggy and hot, but on this night the occasional autumn breeze would creep in and was now beginning to chase some of the summer heat away. Frank Doar was glad to see the heat start to go. He welcomed the cool breeze that blew across the station as he sat back and listened to the crickets sing him a lullaby. The stationmaster was in absolute heaven. As he waited, he began to drift off to sleep in the quiet solitude of the station.

All of a sudden, out of nowhere, an elderly black man appeared at the depot. He was filthy, sweaty, breathless and agitated. He startled Frank Doar as he bounded across the platform. Doar, now wide awake, rose to meet the exhausted man. The moonlight glistened off the sweat in the old man's hair, and in the dark, it almost resembled a halo, thought Doar. The old fellow told the stationmaster that he had just run up the railroad line because the tracks were destroyed several miles back in the direction from where he had come. He further told the bewildered Frank Doar that the old stationmaster needed to act immediately and release warning flares or the train would derail on the twisted tracks and many people would surely die.

The Summerville stationmaster believes an angel intervened during the Great Earthquake of 1886.

Doar had never seen this man before in the tightknit community. He thought he knew everyone in Summerville. He would have ordinarily been apprehensive about such a demand from an absolute stranger, but this man seemed different. Despite the urgency in the old man's voice, Frank Doar felt calm. At the old gray-haired man's insistence, the stationmaster took swift action. He quickly released the emergency flares. As he finished putting out these devices known as torpedoes, he turned to speak to the old man and realized he was gone. He had been there one second and was gone the next. It was as if he had just vanished into thin air.

Frank Doar removed his pocket watch and glanced at it. The visit by the old black man, the story he told and the emergency preparations had taken only five minutes. The stationmaster was marveling at this incredible revelation when just then, at 9:50 p.m., there began an eerie hissing that enveloped the town. As the hissing grew increasingly louder, it was followed by a massive explosion. The earth began to shake violently. Chimneys collapsed, and walls began to fall on the nearby buildings. Trees

swayed violently and uprooted themselves. In a split second, Frank Doar's heavenly evening had been plunged into hell as a massive earthquake struck Summerville and the surrounding areas.

The Great Earthquake of 1886 is considered to be the largest recorded earthquake to ever hit the southeastern United States. It lasted less than one minute yet left a path of destruction totaling over $6 million in damage to the city of Charleston alone. The pre-earthquake value of all Charleston's buildings combined was estimated at only $24 million at that time. Charleston's death toll was around 110, and the quake, if it had been measured by today's modern equipment, would have ranged between 6.6 and 7.3 on the Richter scale.

Summerville was also hit hard, and there was barely a building that was not affected. Although it did not experience the devastation that Charleston sustained, it had considerable damage of its own. Eight houses fell from their supports. Three-fourths of the chimneys in Summerville came down, some directly through their roofs. St. Paul's Episcopal Church was shifted exactly four inches off its foundation. During restoration, it had to literally be lifted up onto supports and screwed back together. Fissures opened in the earth, and geysers erupted from them, shooting water fifteen to twenty feet into the sky. The water would pull great amounts of sand from the center of the earth and leave the large and unique blue and yellow sand deposits where it flowed. Interestingly enough, just 2 people died in Summerville as opposed to the 110 in Charleston.

Down the tracks from Summerville Station, the passenger train was struck by the earthquake. The engineer applied the brakes, but the train only accelerated with each shock. The whole earth rolled as if the land had become a great ocean and the train was a tiny ship left to its mercy. Miraculously, the train rode out wave after wave. As it approached Summerville, warning flares were spotted, and once again the engineer applied the brakes. This time, the train rolled to a halt a mile from Summerville and the horribly damaged tracks. The passengers were badly frightened, but no one was injured.

Another train that had been leaving Summerville heading to Charleston was not met with the same divine intervention. It did not fare so well. At the time of the earthquake, it was passing Ten Mile Hill in the vicinity of what was at that time called Woodstock Station. This was the exact epicenter of the Great Earthquake. The tracks were literally twisted into the shape of an *S*. The train was violently derailed. The engineer in this train was critically injured, and another crew member was killed.

After the quake, the stationmaster, Frank Doar, became convinced that the old black man he had met had actually been an angel in disguise sent by God to save the train heading into Summerville. Doar never changed his story about his encounter or his claim that the old man was an angel. He said so until the day he died.

THE PHANTOM FLIGHT OVER SUMMERVILLE

During World War II, many civilians served as the first line of defense for their hometowns. Such was the case on April 4, 1945, when Betty Jo Waring was on "spotter duty" in the town hall tower. Like so many others in the city and across the country, she had studied the charts that showed the shapes and silhouettes of enemy planes and also those of allied aircraft, but as usual, nothing filled the skies of Summerville other than birds and butterflies.

The highest place in Summerville was the little steeple tower of the city's town hall. Two flights of stairs, a hatchway and then a catwalk took you to the top, where you were to sit, wait and figure a way to pass the long and boring hours.

Betty Jo and the young ladies had figured a way to pass the time.

Instead of plane spotting, they would do a little boy spotting. Young military men were all over the town, so the young ladies would keep an eye out for them from their vantage point in the tower. A young girl would prepare herself for the day's hunt by writing a little note with the date, time and place of the next American Legion party and her name. She would then wrap it around a small stone. When she spotted a group of young men— they almost always appeared in groups—she would throw it at the boy of her choosing, and he would inevitably meet her at the party.

Today would turn out to be a little less boring than Betty Jo Waring was used to, and it was not going to be because of boy spotting.

At about 1:00 p.m. that Wednesday afternoon, a very large and loud plane flew toward town. It was *unusually* loud, and as Betty Jo watched it come in from the east, she saw parachutes begin to open in the sky one by one. Ten in all opened as the plane began to make circles. Stunned at what she was seeing, she watched the invaders drift through the air toward town. She returned her focus to the loud plane, and as it flew over, she recognized the large bomber. It was one of ours! The plane was a B-24 Liberator Bomber. It was a massive plane with a 110-foot wingspan and weighed about fifty-five

thousand pounds. It had a maximum speed of 303 miles per hour, and it was armed with eleven .50-caliber machine guns. It also could accommodate eight sixteen-hundred-pound bombs.

The plane began to level out. In his classroom, Bobby Anderson was staring out the window. He could not believe his eyes as the large plane passed over, sputtering. It barely cleared the store across the street before clipping the treetops and making a "ghastly whizzing" sound. To the young seventh grader, it sounded as if the plane had run out of gas as it sputtered along above the trees and disappeared. A violent crash followed that rocked the entire town.

Bobby and his classmates jumped to their feet, raced across the classroom and were out the door. They gathered on the football field with the other students and watched the little white parachutes drifting in the April sky. A large number of the faculty stood shoulder to shoulder in an attempt to prevent the students from entering the woods. It was a useless strategy. The young boys raced around the teachers and down the path. The plane did not explode but did make a massive crater. The boys reached the smoking wreckage and began scavenging souvenirs from the crash site before the authorities arrived. They took these treasures back to their tree house. A damaged propeller, assorted gauges and radio equipment soon converted their tree fort into a make-believe version of the plane they had cannibalized. Bobby Anderson and his friends were happy with their haul but a little disappointed that they had not gotten a machine gun before everyone else showed up—and they *all* showed up.

The townspeople lined the road on foot, on horseback, in wagons and in cars as they hurried to the burning plane. Eventually, the authorities showed up and extinguished the flames. The military showed up and retrieved what it wanted. Then the bulldozers showed up and buried the rest.

Miraculously, no one was hurt on the ground, despite such a large plane crashing into the city. In the air, all the crew members were able to abandon the plane and parachute to safety. All the airmen survived. It was truly a miracle because just eight months before, a similar event had occurred in England, and the school did not fare as well as Summerville did.

On August 23, 1944, in the village of Freckleton in Lancashire, England, a United States Army Air Force B-24 crashed into the Holy Trinity Church of England School. It then destroyed an additional three houses and also the Sad Sack Snack Bar before crossing Lytham Road and erupting into a ball of flames. In total, sixty-one people were killed. Thirty-eight of the deaths were children.

The subsequent military investigation revealed that two B-24s were in a test flight before being delivered to the Second Combat Division. At about 10:00 a.m., the planes were recalled due to a violent storm. Visibility was reduced, and wind gusts were quickly approaching sixty miles per hour.

Unlike the plane in Summerville, this time the planes approached from the west. The planes approached Warton Aerodrome, and at the last minute, the second plane aborted its landing to circle around and line up for a second attempt. As it attempted the maneuver, the aircraft's right wingtip clipped a treetop and then ripped away as it hit the corner of a building. The plane's fuselage continued on, destroying the houses and the snack bar. A portion of the aircraft struck the infants' wing of the school. Fuel from the ruptured tanks ignited and engulfed the entire infants' wing in a sea of flames. A melted clock in one of the classrooms stopped and marked the time of the disaster as 10:47 a.m.

Thirty-eight children and six adults were killed in the school. The Sad Sack Snack Bar was a location that catered to the servicemen from the air base. Seven American servicemen, four Royal Air Force airmen and three civilians were killed at the snack bar. The three crewmen on the aircraft also died. This time, the skies over the city were not clear, parachutes were not deployed and scheming young boys did not race to the crash site. Death, fire and destruction rained down on the little village of Freckleton.

Today, Robert Anderson looks back on that day and reflects. The military came in and buried the wreckage. No one knows what the plane was doing and why it ended up over Summerville. Mr. Anderson speculates that it had been patrolling the coast searching for Nazi U-boat submarines, but if that were the case, why didn't it ditch into the sea instead of risking civilian casualties? The answer is unknown. In fact, the local paper carried no report of the crash. This can be attributed to the fact that secrecy was key during World War II, and censorship did not want that information broadcast.

What is interesting is that a request I submitted to the Air Force Historical Studies Office, which maintains records, historical data and archives, was returned claiming that no crash ever occurred on that date or in Summerville, South Carolina. The crash does not exist, and the flight did not exist.

It is truly a phantom flight.

The official seal of Summerville bears the Latin phrase *Sacra Pinus Esto*. Translated, the phrase reads "Sacred is the Pine." On April 4, 1945, God indeed found the pines of Summerville to be sacred. In fact, the pines were sacrificed for the children of Summerville. "If that plane had hit the school, it would have destroyed an entire generation of Summerville

descendants," states Robert Anderson. He truly knows how blessed he is and how blessed the little town of Summerville is in light of the disaster that could have been.

Psalms 103:12 reads, "As far as the east is from the west, so far hath he removed our transgressions from us." The plane that entered Summerville came from the east. The one over Freckleton came from the west. What a vast difference in the outcome.

THE LEGEND OF THE SUMMERVILLE MONGOOSE

Although this tale does not deal with ghosts or the paranormal, no collection of Summerville tales would be complete without including this bit of Flower Town lore.

Many, many years ago, Marshall and Lowndes Bailey ran a service station and fuel oil business in Summerville. They were quite active, but in January things usually slowed, and the two brothers became bored. At Christmas, they were busy creating elaborate holiday decorations, and in the spring they were well known as the designers and creators of parade floats that carried many of the teenage high school queens down Main Street. This was now the cold, dreary stretch between the Christmas holiday season and the spring parades. They were cold, tired and extremely bored. That is, they were bored until they acquired a most curious oddity.

They acquired a mongoose.

How exactly they acquired that exotic creature we will cover later, but for now, we will say that their mongoose attracted a lot of attention. People would hear of the Baileys' mongoose and come from far and wide to see it.

In fact, Frank Smith and his wife, Annabel, had both seen the magnificent creature and eventually told their story to the *News and Courier* newspaper in Charleston. Their story of the Summerville mongoose actually made it into Ashley Cooper's column, "Doing the Charleston."

Eventually, the Baileys' mongoose attracted the attention of John Weber, a local mechanic. After much begging and pleading from Mr. Weber, the Baileys relinquished custody of the mongoose to the ecstatic Weber. As soon as the mongoose wound up at John Weber's garage on the edge of town, word got out, and the same thing happened to Weber. People came from all around to see the mongoose and laugh and marvel at the magnificent creature. Weber and his colleagues relished in the notoriety.

One cold, icy day, John Weber was working on a customer's truck when three well-attired gentlemen appeared at the shop. They asked if they could see Mr. Weber. In response to the gentlemen's inquiry, the other mechanics pointed to a pair of legs sticking out from under the truck. The men approached the truck and waited for the clanging and banging from underneath to subside.

"Mr. Weber, we hear that you have a mongoose."

"Why, yes." Weber rolled the squeaky creeper he was laying on out from under the truck. "Would you like to see it?"

"We most certainly would," came the eager response.

Mr. Weber took a rag from his pocket and wiped the grease from his hands as he walked over to a little wooden box on an old table in the back of the garage. It was a roughly constructed box made of wire and wood and had a good deal of straw sticking out of it. It was not much bigger than a large shoebox. John Weber gave his usual spiel about what a mongoose was and where they came from. He also told the men how he had come to acquire it from the Bailey brothers, a feat that he obviously took pride in.

Weber stepped closer to the table. He bent down and tapped the box carefully, and a little bushy tail emerged. He advised the gentlemen that the creature was nocturnal and was most likely sleeping. He told them to be quiet and that they needed to draw closer so they could get a good look when he opened the box. He also told them not to make any sudden movements to startle the animal because if it escaped, they would have a hard time catching it. After all, any animal fast enough to catch and kill a striking cobra in India would give the group of Summerville mechanics in the shop a run for their money.

The three men drew closer. As they bent down to the box, the furry tail convulsed and leapt out at their faces. After the shrieks and profanity subsided, the whole garage erupted in laughter. The mongoose was nothing more than an elaborate hoax and practical joke! The Bailey brothers had constructed it out of an old gray foxtail and a spring. Once they tired of the joke, they gave it to their friend John Weber.

What makes the joke even funnier is that the three men were federal customs agents sent to confiscate the mongoose. After they had composed themselves, they revealed who they were and also the fact that they had been conducting an investigation into the Bailey/Weber mongoose. They explained that there was serious concern about how the creature had come into the country and made its way to Summerville. There was also concern about how it would affect the area's ecosystem should it escape. They explained that the country had already experienced an issue with the Asian mongoose in Hawaii. It was

introduced in 1883 to several Hawaiian Islands in order to control the snake and rat populations on the sugar cane plantations. Instead, the seventy-two mongooses that were released hunted native birds and devoured bird eggs, threatening to annihilate many local species. They also bred rapidly, and their population soared astronomically. With this rapid population explosion, there was genetic diversion from inbreeding and crossbreeding with local indigenous creatures. These mongooses were also discovered to be carriers of a disease known as leptospirosis, or Weil's disease, which can be contracted by humans. As you can see, the introduction of this species did not benefit Hawaii at all, and in fact, most Hawaiians considered the mongoose to be a plague to the sugar cane plantations rather than an asset.

The three agents had been assigned to investigate the case, confiscate the mongoose and bring charges against the Baileys and Weber if need be. The potential threat to Summerville, its citizens and its ecosystem was so serious that it had attracted federal attention and warranted a criminal investigation.

No charges were brought against the Baileys or John Weber, but the men did indeed confiscate the mongoose, cage and all. They could not wait to get it back to show their supervisor in the same manner that the Summerville mongoose had been presented to them!

This story speaks to the close-knit ties Summerville residents have. No one revealed the fact that the mongoose was a practical joke, although numerous folks had fallen victim to it. In fact, they had kept the truth of the mongoose so closely guarded that it had reached the level of creating a federal investigation.

I am quite sure John Weber and the Bailey brothers never forgot their near arrest by the well-dressed trio of federal agents, and I am positive the federal agents never forgot their encounter with the Summerville mongoose.

THE PIANO

In the latter part of the 1990s, a young married couple lived with their small children in a little three-bedroom home in the Barony Ridge subdivision. The tiny little home was located in the quiet neighborhood just off Bacon's Bridge Road on the backside of Summerville, on the outskirts of town. The young man was a business professional and worked many long and unusual hours to enable his wife to be a stay-at-home mom. They both felt that the children needed her at home, and he did not mind. Despite a crazy

A Summerville family is paid a visit by a phantom pianist.

work schedule and small children at home, both he and his wife were also heavily involved in their church and with work in the children's ministry. The wife was also the pianist of the church they belonged to.

One afternoon, the young man came home from a long, tiring workday and found his wife feeling ill. He told her to go to bed. He would take the children with him to purchase some fast food, giving her an opportunity to get some much-needed peace and quiet.

The young man gathered up the children, herded them out the door, loaded them into their minivan and started out in search of Walmart, McDonald's and "Happy Meals." Just the mere mention of those two words together brought squeals of excitement from the youngsters. Dad was a hero.

No sooner had he traveled just a few blocks away than the giggles and squeals were interrupted by the beeping sound of his pager going off. He removed the annoying device and looked down at it. In an instant, he realized it was his home number followed by a series of repeating "911." This was a code he had established with his family, and obviously this had to be his wife paging him with some sort of emergency back at their house. The man reached for his cellphone and realized he had left it in his vehicle during the chaos of rounding up his children and getting them into his wife's van. Now, with no means of communication, he became extremely concerned and frightened for his wife. All types of thoughts and horrible scenarios raced through his head. Nearing panic and with no other option, he turned the vehicle around and raced home.

As he arrived back at the residence, he was relieved to see his wife standing in the yard. As he slowed the vehicle to make the turn into the yard, he could see that she was visibly shaken and ghastly pale. She ran to him before he could even pull into the driveway and immediately began telling him about her emergency.

It was the piano.

She told him that she was resting in the bedroom when she heard the piano in the living room begin to play. She said it was not just a single key but

three distinct chords. Knowing that she was the only one home, she called her husband and fled the house, fearing there was an intruder. The young man had his wife sit down in the vehicle, and he entered the house. He went into the bedroom and retrieved his pistol, which was concealed in the closet. With the information his wife had provided him about the piano, he felt foolish to provide that information to police, so he opted not to contact them and chose to search for the culprit himself. He felt sure that he could detain a burglar if he located one, but with the information his wife had told him, he had his doubts. He looked everywhere an intruder could hide but found no one He then tried to re-create the occurrence, but although he was able to produce single notes on the piano, he could not create a way to produce three distinct and separate chords on the instrument. He gave up and joined his wife, who had climbed into the driver's seat of the still-running van parked in their driveway. The family pulled out of the driveway and began a new quest for fast food.

The young man began to good-naturedly tease his wife about her invisible phantom pianist and the fact that it only knew three chords. He could tell by the look on his wife's face that she did not find the matter humorous. He thought that in this case discretion was indeed the better part of valor, and he chose to leave the matter alone.

As they approached the intersection where Bacon's Bridge Road and Old Trolley Road intersect, they noticed that traffic had begun to back up, and they slowed to a standstill. Emergency vehicles were responding from every direction with lights flashing and sirens wailing. After waiting in the non-moving traffic for several minutes, they turned around and headed back in the opposite direction to visit the McDonald's on the other end of town.

Later that night, the young couple was relaxing in the bedroom after having fed the kids and put them to bed. The husband turned on the television, and the two began watching the news. In complete disbelief, they watched as the news reported that there had been a major accident with fatalities at the intersection of Bacon's Bridge Road and Old Trolley Road that evening. The man was completely speechless. Apparently, the accident had happened just seconds after he had received the page from his frightened wife and had turned the vehicle around. The realization then hit both of them that this was a horrific accident in which he and his children would undoubtedly have been involved had he not turned around because of the frantic page from his wife. Be it angel or ghost, intruder or alien, there was no denying the fact that his and their children's lives had been spared by the actions of his wife—and the phantom pianist.

A LIVING LEGEND

The James F. Dean Community Theater on South Main Street is currently the home of Summerville's Community Theater Group known as the Flowertown Players. Founded in 1976, the Flowertown Players purchased and renovated the 209-seat theater and named it after one of their founders. The community theater group continually presents a wide variety of productions, from musicals to drama to comedy.

The theater itself was built in 1935 and was a popular motion picture theater until the 1960s. It was known as "The Show" to the residents of Summerville and the surrounding area. It was also known for its collection of animal trophies. Everything from native whitetail deer to exotic African lions adorned the walls. These were taken by the owners while on safari in various places around the world. The owners had been on many expeditions for National Geographic and also the American Museum of Natural History.

When one thinks of a safari, inevitably one thinks of a man, larger than life, facing man-eating lions or charging rhinos and never showing an ounce of fear. Images of John Wayne in the 1962 movie *Hatari* or Clint Eastwood in the 1990 film *White Hunter, Black Heart* are conjured up from memory. This is the fiction of Hollywood and the movies shown in the humble little theater in the tiny town of Summerville. The animals on the wall at The Show were not taken by a rugged male stereotype. Quite the opposite is true. In fact, the majority of the animals were taken by Gertrude Sanford Legendre—a

The James F. Dean Theater's former owner was a big game hunter, socialite and spy.

82

woman. In fact, she was probably the most remarkable woman ever to set foot in Summerville, and the motion pictures shown in her theater paled in comparison to the remarkable life she lived.

Born in 1902, she was the daughter of New York carpet magnate and House of Representatives member John Sanford. Her grandfather, Stephen Sanford, was a prominent businessman and chief executive officer of the Bigelow Sanford Carpet Company. Within this family, she became a socialite.

As a teenager, she begged her parents to let her go hunting after her graduation from high school. She much preferred this to becoming a debutante. Her parents granted her wish, and she killed her first elk in the Grand Tetons of Wyoming. She was hooked on big game hunting after that and eventually became involved in expeditions to exotic lands. In 1923, at the age of twenty-one, she began traveling the world as a big game hunter. It was on a safari expedition to Abyssinia in Africa for the American Museum of Natural History that she met her husband, Sidney Legendre. It was also on this expedition that she was almost killed.

At daybreak one morning, her guide spotted four lions, but as they approached, the lions started to move away. Gertrude Legendre fired once and struck a lion in the stomach and leg. The shot did not bring down the lion, and he managed to escape into the brush.

As they began tracking the injured animal, she caught another glimpse of him and managed to get off a second shot, only to see him vanish once again even deeper into the brush. They tracked him to a very dense, bushy area where they heard him growling. They waited for approximately thirty minutes before the growling subsided. Figuring the animal had succumbed to his wounds, they approached. They found where he had been lying soaked in blood, but the lion was nowhere to be found. They were now in the dense brush with a living lion—a very large, angry and injured lion.

As they huddled down in a tunnel created by a thorn bush, they heard a roar from about twenty feet away. The injured lion charged, and Gertrude's colleagues fired blindly at the beast. Another hunter within the group, O.M. Reese, wheeled around and fired both barrels of his Holland and Holland .470-caliber rifle. The lion skidded to within ten feet of the horrified group. They remained frozen in shock for several minutes before regaining their composure.

Gertrude Legendre continued as a big game hunter until 1929. She had many adventures hunting game and even had a standoff encounter with a tiger that stalked her in her blind for fourteen hours before she was able to get a shot at him.

Gertrude Legendre spent many years being the hunter, but a series of events led to her being the hunted in 1944. She would find herself no longer the predator. This time, she was facing the rifle.

During World War II in 1942, Mrs. Legendre took a job in Washington managing the cable desk for the Communication Branch, which later evolved into the Office of Strategic Command, or OSS. She handled sensitive and top secret documents for the division. By 1944, she was transferred to Paris and obtained the rank of second lieutenant in the Women's Army Corp. She also became a spy for the OSS.

On September 23, she was traveling through the Western Front in France with Major Max Papurt; Bob Jennings, an agent of the OSS; and their driver, Private First Class Dick, in a jeep near enemy lines. Near Wallendorf, PFC Dick slowed the vehicle down, and a bullet struck the front fender. Major Papurt grabbed a rifle, jumped from the jeep and began attempting to locate the German sniper. The driver inched the vehicle along and had barely gotten ten yards when Legendre, Bob Jennings and the driver had to exit the jeep and use it for cover. With the next burst of gunfire, PFC Dick screamed out in agony and collapsed in the road beside the jeep. Legendre crawled to his side to tend to his wounds. When she reached the injured soldier, she slowly and carefully peered up over the floorboard of the vehicle. Just as she did this, a round hit the front axle and ricocheted into the crankcase, spraying hot oil into her face. At that moment, Bob Jennings ran and grabbed Major Papurt, who had been pretending to be dead to avoid being shot again, and pulled him from the open roadway to cover behind the jeep. All four were now pinned down behind the vehicle, lying together in a mixture of slime, mud, blood and oil. Realizing that the situation was hopeless, Jennings tied a white handkerchief to the end of the major's rifle and hoisted it high above the jeep. In a few moments, the gunfire stopped. Bob Jennings and Gertrude Legendre quickly burned their OSS identification before they were swarmed by Nazi soldiers.

Gertrude Legendre and her colleagues were taken prisoner. She would spend six months as a prisoner of war, the first American woman to become one. Major Papurt would eventually die during an air raid while still in captivity. Bob Jennings was also imprisoned. PFC Dick was never seen again after being taken into captivity.

Mrs. Legendre was moved from location to location and was interrogated by the Gestapo but never revealed her assignment. Eventually, she was able to escape with the help of a German lieutenant. She escaped across the Swiss border. After the war, she used her connections to find the German lieutenant and helped him and his family flee Germany and settle in America.

Most people sat there and watched their movies, oblivious to the fact that the owner of the humble little theater in their quiet little town had been a socialite, a big game hunter, a spy, a prisoner of war and one of the very few people to ever escape Nazi captivity. Perhaps they sat laughing at the antics of Cary Grant and Katherine Hepburn in the 1938 film *Holiday*. As they became enchanted by Ms. Hepburn's character Linda Seton, they never knew the character was based on the theater's owner. As they watched great actors become legends on the silver screen, they never knew how close to a living legend they actually were.

A Most Unusual Footrace

Since its initial race in 1978, Charleston, South Carolina, has been home to the Cooper River Bridge Run. The first race had only 1,350 entries and was shortened to 9,850 meters. Today, thirty-four years later, the Cooper River Bridge Run has become an annual 10K (6.2 miles). It is truly an international event that attracts runners from every corner of the globe.

April 2, 2011, drew one of the largest groups of participants. Over forty thousand people competed, and the event drew worldwide attention, but long before the Cooper River Bridge Run was even dreamed of, another race, in Summerville, captured the attention of the world. This race was between only two runners—but one of them had four legs.

On June 20, 1941, only six months before Japan pulled Summerville and the rest of this country into World War II, the city hosted a most unusual race. This was a marathon race, but unlike a normal marathon, which in order to be official has to be 26.2 miles, this race was 40.0 miles long. That was still not what made this race so unusual. What made this race so peculiar was the fact that it was a competition between a man and a horse.

On a blistering hot summer day, with temperatures reaching 110 degrees, the two contestants met on Main Street in Summerville. The man was a forty-year-old Finnish doctor who operated a health and fitness farm in the city. His opponent was an eleven-year-old horse named Duke, owned by Albert Peters.

Duke was trained by John Finucan. The horse was trained to trot for eight minutes and walk for four minutes. This was according to existing United States Cavalry regulations. The horse would also have a five-minute break and rubdown every hour and also would be supplied with two quarts of water. Four riders would alternate riding the horse in the competition.

A most unusual footrace took place in Summerville, except one of the contestants had hooves. *Photo by Kayla Orr.*

The race would go down Highway 61, or River Road, past Magnolia Plantation and Middleton Plantation, cross the Ashley River, go into Charleston and end at the Citadel Military College. This would be the first leg of the race and would measure twenty-seven miles. The second leg was thirteen miles around the Citadel's track, where people could watch the spectacle by purchasing a ticket, fifteen to twenty-five cents each. The race actually garnered a total of sixty-five dollars, which was divided between the American Red Cross and the Finnish Relief Fund.

Exhibitions like this had been held before, but only at short distances. These "sprint" races would be for distances of only 100 to 140 yards. Although no official records were kept, this marathon race is still believed to have been the longest man-versus-horse marathon ever held.

Mayor Grange Cuthbert stood on the steps of town hall and fired the signal for the race to begin. The group was led by troopers from the South Carolina Highway Patrol and followed by at least one hundred cars, cyclists and other horse riders.

The doctor alternated running and walking. He would take occasional breaks for cool drinks of orange or pineapple juice and oil massages. Nonetheless, the horse took the initial lead early, but by the three-mile marker, the horse had a half-mile lead. They changed lead positions a total of ten times. This usually occurred as the doctor took his break. This went on in the grueling 110-degree temperature for seven hours.

The horse entered the track, but by this time the doctor had fallen back, complaining of blistered feet. He had dropped back, removed his shoes and continued barefoot but could do so no longer. He fell behind the horse and lost with only five and a half miles to go. Horses have been known to "throw a shoe" and lose a race, but this was the first—and perhaps only—time that a man threw a shoe and lost a race to a horse!

TOBY

In the middle of Summerville, in the center of Azalea Park, stands a life-sized statue of a yellow Labrador retriever. He sits solemnly by a park bench as if he is patiently waiting for his master to return. Beneath the statue, there is a plaque that reads, "Toby—In Celebration of the Life of John McCurdy Brooks—August 1922 to June 1999." The fact that there is such a statue may seem unusual to most, but then again, Toby was a most unusual animal.

The Brookses lived in the Sangaree subdivision on the outskirts of town. John Brooks was a former navy chief machinist's mate and was retired from the Naval Weapons Station. He and his wife, Joann, enjoyed being a part of the rural neighborhood away from the traffic and noise. He was an avid golfer and loved his garden. It was a place where he found peace and solitude. The last thing they needed was chaos arriving in the neighborhood—but it did. And it arrived in the form of a scrawny yellow Labrador retriever.

Since their neighbor owned a dog, this lone stray dog chose to take up residence in the Brookses' backyard. That is what the Brookses thought at first, and they, like most in the neighborhood, considered him to be a nuisance.

Animal Control was called but could not catch the creature. A cage trap was set, and the dog simply ignored it. The Animal Control officers pulled out all stops and even went so far as to purchase a steak as bait to lure the dog into the trap. Once again, the dog ignored the trap and stayed far away from it.

Toby sits patiently in Azalea Park.

The Brookses even became involved and mixed a tranquilizer with a treat, which the dog actually accepted. The tranquilizer took effect, and Animal Control was summoned. When the officers arrived, the sedated dog leapt to his feet and ran away as they approached him. Animal Control gave up.

No one could get near the Lab. The skittish dog would not allow anyone to come close to him. Joann began to leave him food, which he accepted, but he still would not allow her to touch him. She named him Toby. He would come when she called, but he never allowed her to touch him.

One stormy night, the dog came up from the backyard shivering and soaking wet. He stood staring at Joann, shaking and soaked. She reached down to the dog, and this time he allowed her to put her arms around his neck and hug him. She was ecstatic to finally have won the dog's trust.

John Brooks was less enthusiastic. The dog dug holes in his garden and rooted up the shrubs. John was a cat person and had nothing to do with the dog. He told Joann the dog had to go.

But the dog stayed.

In February 1999, John Brooks became extremely ill. On February 14, 1999, he was rushed to the Emergency Room at Roper Hospital. The prognosis was not good. The couple's Valentine's Day was devastated by the horrifying revelation that John Brooks was terminally ill.

As John's illness progressed, he could do less and less. The threat of infection prevented him from leaving the house, and he was restricted

more and more in what he could do. First, the illness deprived him of his ability to play golf. It later robbed him of his ability to work in the garden he so enjoyed.

One day, he was sitting in the garage, and the dog came over to him. He ducked down and stretched his head out just barely close enough for John Brooks to pet him. Pretty soon, he was following the extremely ill man around everywhere. They became inseparable.

The dog took up residence in the Brookses' garage. He began to allow the neighborhood children to pet him and became known as the "neighborhood dog." Even though the neighborhood considered him its dog, Toby adopted the Brookses and was loyal to them. When John Brooks was down, the dog reflected his mood. When John Brooks entered the hospital, the dog whimpered and whined. He stayed close to Joann, and they comforted each other. When John died in June, the dog remained with Joann as a constant source of comfort. They shared their grief at the loss of John. For two months, the dog provided comfort and companionship, and then in August he disappeared. A few nights later, Joann found the dog standing in the garage. It was a rainy night, much like the night he had first allowed Joann to touch him. They shared a quiet moment, and then Joann went inside to go to bed.

The next morning, she let Toby out of the garage. The dog walked around the house slowly and returned to the front yard, where he sat down. He just stared blankly at the house for some time, and then he got up and simply walked away. Joann called to him, but he never turned around. Perhaps his work was finished, and goodbye was just too hard for the creature.

They say that God works in unusual ways, and indeed the comforter He sent to the Brooks family in their time of need could not have been any more unusual than a scraggly yellow Labrador retriever called Toby.

Behold, I send an Angel before thee, to keep thee in the way, and to bring thee into the place which I have prepared.
—Exodus 23:20

The following year, the Summerville Town Council approved the addition of a statue created by Florida artist Sandy Proctor. The statue was purchased by Joann Brooks and donated to the city. It was added as part of the "Sculpture in the South" exhibit in Azalea Park. The statue not only stands as a memorial to the life of the husband of one of the city's citizens, but it also stands as a monument to the unconditional love exhibited by the furriest angel God ever sent to Summerville, South Carolina.

III
LEGACY

THE FUTURE OF SUMMERVILLE'S PAST

S ince its humble beginnings, Summerville has grown from a meager handful of citizens seeking to escape the heat and mosquitoes of plantation life to a highly diversified population of over forty thousand. Its dirt roads, which were once traveled by horse and wagon, have evolved into multilane parkways crowded with automobiles. Its corner grocery stores, which delivered to people's homes, have given way to larger chain stores. If you want something delivered, you use your home computer to order it. The hustle and bustle has definitely reached the city, and it has changed dramatically in so many ways. Still, there is a need to maintain its connection to the past in hopes of preserving it for our future.

In 1973, the Summerville Preservation Society was founded in order to do just that. Its efforts resulted in the city being added to the National Register of Historic Places and the Inventory of Historic Places in South Carolina. It continues to make advances in preservation efforts for the city and to attract new members (such as myself) to its cause.

The preservation effort continued, and the 1980s saw Summerville, the "Flower Town in the Pines," designated as a Tree City, USA. The following decade saw the creation of the Summerville Dorchester Museum. As stated earlier, much of the actual history concerning the beginnings of Summerville has been lost. This is what motivates others to preserve what is known, the connections with the past and the advancements toward the future.

As Summerville grows, expands and evolves, it will be interesting to see how growth affects the legends of the town. Sections of Sheep Island Road

Follow the Leader, a statue dedicated to the future generations of Summerville.

have been purchased for development, and it will be interesting to see how the Summerville Light adapts from being a remote and rural "ghost" to being a residential one. Will it turn up at someone's backyard picnic? Perhaps it will turn up in someone's living room. It will be most interesting to see how the new residents interact with a long-deceased widow who refuses to give up her eternal search for her husband.

Will the praying soldier at the Quackenbush-List House have a prayer for the new owners? The house is currently on the market and available for purchase, so it will be interesting to see what new interactions will take place. Perhaps the new owner will be successful in locating the alleged grave underneath the home.

As we have seen throughout the stories in this book, the locations evolve, yet the hauntings remain constant. Technology evolves, yet the ghosts remain the same. The ghosts never change.

When I was a young boy, I received a book, *Charleston Ghosts*, as a gift. It was a book I had repeatedly begged—and bugged—my mother for. The book was written by Margarett Rhett Martin and quickly became a favorite. In the book, the author not only told the stories of many of the hauntings associated with the city of Charleston, but she was also able to paint in words images of the history of the city and the times in which the events took place. The stories within the book and the style in which she conveyed them made an indelible mark on a very young boy. Now, that young boy has grown into

a man and hopes he has been able to do the same for the next generation with *Haunted Summerville*.

It is my sincere hope that this book ensures both the future of Summerville's haunted and historic past and perhaps plants a seed in another future writer, much as Miss Martin's work did for me.

BIBLIOGRAPHY

Applegate, Debbie. *The Most Famous Man in America: The Biography of Henry Ward Beecher.* New York: Three Leaves Press/Doubleday Publishing, 2006.

Bass, Robert D. *Swamp Fox: The Life and Campaigns of General Francis Marion.* Orangeburg, SC: Sandlapper Publishing Company, 1974.

Baxley, Sandra. "Ghostly Summerville Light Still Makes Nightly Rounds." [Charleston] *News and Courier,* November 12, 1970.

Cisco, Walter Brian. *Henry Timrod: A Biography.* Cranbury, NJ: Fairleigh Dickinson University Press/Rosemont Publishing and Printing Corp., 2004.

Collins, Bill. *Reflections of Dorchester County, South Carolina.* Marceline, MO: Summerville Journal Scene/D-Books Publishing, Inc., 2002.

Danelek, J. Allan. *The Case for Ghosts: An Objective Look at the Paranormal.* Woodbury, MN: Llewellyn Publications, 2006.

Derrick, Samuel M. *The Centennial History of the South Carolina Railroad.* Columbia, SC: State Publishing Company, 1933.

Harden, John. *Tar Heel Ghosts.* Chapel Hill: University of North Carolina Press, 1954.

Huneycutt, Shirley. "Halloween Visitors?" *Summerville Journal-Scene,* October 27, 1978.

Hutson, Heyward, and Willette Fey. "Ghost Haunts Quackenbush-List House." *Summerville Journal-Scene,* February 5, 1997.

Kwist, Margaret Scott. *Porch Rocker Recollections of Summerville, South Carolina.* Summerville, SC: Linwood Press Inc., 1980.

Legendre, Gertrude Sanford. *The Time of My Life*. Charleston, SC: Wyrick and Company, 1987.

Manley, Roger. *Weird Carolinas*. New York: Sterling Publishing Company, 2007.

McIntosh, Beth. *Beth's Pineland Village*. Edited by Clarice and Lang Foster. Columbia, SC: R.L. Bryan Company, 1988.

———. "Restoring 1811 Hunting Lodge Work of Love." *Summerville Scene*, August 15, 1973.

McPherson, James M. *The Negro's Civil War: How American Blacks Felt and Acted During the War for the Union*. New York: Pantheon Books, 1965.

Petersen, Bo. "Dog Gave Comfort to Couple." [Charleston] *Post and Courier*, December 13, 2000.

Rugoff, Milton. *The Beechers: An American Family in the Nineteenth Century*. New York: Harper and Row Publishers, 1981.

Schipani, Deidre. "Montreaux's Bar and Grill: Beer and Burgers Bloom in Summerville Restaurant." [Charleston] *Post and Courier*, June 11, 2009.

Smith, Nick. "Who Ya Gonna Call? Darkwater Investigates the Paranormal, but Don't Call Them Ghostbusters." *Charleston City Paper*, October 29, 2008.

Walker, Legare. *Dorchester County*. Ellen Walker Cuyler, Josephine Walker Parker, Randolph Axson Walker, William Law Walker, Grace Walker Winn, USA, 1941.

Walser, Richard. *North Carolina Legends*. Raleigh: North Carolina Department of Cultural Resources, 2004.

Walsh, Norman S. *Plantations, Pineland Villages, Pinopolis, and Its People*. Virginia Beach, VA: Donning Company Publishers, 2006.

Wikipedia. www.wikipedia.org.

ABOUT THE AUTHOR

Photo by Kayla Orr.

Bruce Orr was raised in the Lowcountry of South Carolina and grew up hunting and fishing on the plantations of Berkeley County with his father and brothers. It was during those times that he spent many evenings listening to the tales and legends surrounding this historic area. As a young boy, he had an insatiable appetite for the bizarre, unexplained and paranormal and was always searching for answers behind the events he heard about at the hunt clubs and fish camps.

As he grew into an adult, this natural curiosity in seeking facts brought him into law enforcement, where he eventually became a detective and supervisor within his agency's Criminal Investigative Division. Now retired, he uses the skills he obtained in his career to research the legends and lore that he grew up with in order to record and preserve them for future generations.

Visit us at
www.historypress.net